IMAGES
of America

SOUTH SANTA CLARA COUNTY

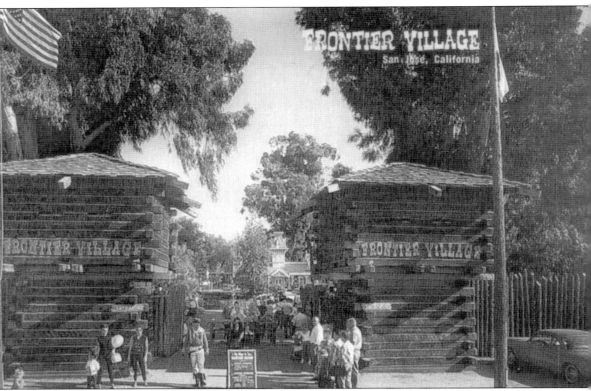

Frontier Village, a south San José family amusement park, operated from 1961 through 1980.

IMAGES
of America

SOUTH SANTA CLARA COUNTY

Sam Shueh

ARCADIA
PUBLISHING

Published by Arcadia Publishing
Charleston SC, Chicago IL, Portsmouth NH, San Francisco CA

Printed in the United States of America

Library of Congress Catalog Card Number: 2008920088

For all general information contact Arcadia Publishing at:
Telephone 843-853-2070
Fax 843-853-0044
E-mail sales@arcadiapublishing.com
For customer service and orders:
Toll-Free 1-888-313-2665

Visit us on the Internet at www.arcadiapublishing.com

*To my uncle Sun Daolin, a famous actor and movie director who
suddenly left us after a 57-year acting career*

CONTENTS

ACKNOWLEDGMENTS

As a resident of Santa Clara County for 30 years, I have been fortunate to witness its evolution from an agricultural base to a technology center. My family had lived in the same house in China for 260 years, and I always enjoyed hearing stories about everything that had happened within its walls. So it is natural for me to be intrigued by the old homes in Santa Clara County and wonder who lived there and how they lived. Whenever I hear that a place is being demolished, I quickly bring my camera to document a bit of local history.

Over the years, I have added a number of interesting papers to my collection: a letter from Tennant Station, a Wells Fargo coach letter, and an 1871 Oak Grove School census marshal's document signed by José Bernal. These and other treasures demonstrate the richness of our local history. Some of the captions in this book are based on articles I have written; the rest are the result of additional research.

I thank Tom Howard and Lucy Solórzano of the Gilroy Museum for providing many of the sources and explanations about the Gilroy and Pacheco areas. While some descriptions are based on oral histories from pioneers, others come from longtime residents such as Paul and John Ward, Erving and Dee Gunter, Gene Guglielmo, and Toshiko Masuoka. I am indebted to the *Morgan Hill Times* and to Bud O'Hare and Gloria Pariseau of the local historical society for information about the Morgan Hill area. For help with the Uvas Valley, I credit Delores Sepeda for her enthusiastic willingness to share her heirlooms. As for public special collections, thanks are extended to Stacy Mueller of the California Room, Charlene Duval of Sourisseau Academy, and county archivist Mike Griffith. Because materials are scarce, in return for their help I donated copies of some of my items to their collections. I extend my thanks to John Drew for sharing his rare post office memorabilia from the 19th and 20th centuries.

Finally, I wish to thank Beth Wyman for clarifying some points and for contributing the foreword. As a former commissioner of historical heritage, she began a local history project of interest to me.

During my oral interviews, I often heard tears in the voices of local residents as they recalled those who had passed on to the next world. Many of the old images are now gone. I was deeply touched as the residents urged me to go on documenting what is left.

I also wish to thank Kelly Reed at Arcadia Publishing for her guidance and Laurie Rendon of Better Edit for her skillful editing. Last but not least, I am grateful to my wife, Lilie, for her patience and understanding and to Krissy the cat for letting me use her napping place as a desk. Now they know why I, a realtor, stop in the middle of nowhere to study crumbling buildings.

FOREWORD

Deciding to compile the history of any place takes a certain amount of self-confidence, as well as lots of time and patience. Determining that the story is complete demands courage because, of course, there is always something more. I commend all who have made the effort. Each perspective adds new dimension to the place in which we live. My congratulations to Sam Shueh, whose remarkable endeavor has brought together all of South Santa Clara County. His contributions include many original resources and research, which help us to see the broader view.

Beth Wyman
Author, *Hiram Morgan Hill*, 1990
Mayor, City of Morgan Hill, 1982–1983
Santa Clara County Historic Heritage Commissioner, 1983–1999

INTRODUCTION

Renowned conservationist John Muir was stunned by the breathtaking rural beauty of southern Santa Clara County. In 1868, he wrote, "It was bloom time of the year. . . . The landscapes of the Santa Clara Valley were fairly drenched with sunshine, all the air was quivering with the songs of meadowlarks, and the hills were so covered with flowers that they seemed to be painted." At one time, the South County was the world's largest producer of prunes and apricots, and the sweet smell of cherry blossoms wafted over the fertile land of "the Valley of the Heart's Delight," now known as Silicon Valley. Even now, in the springtime, the fruit blossoms extend as far as the eye can see, although the rise of Internet technology and fine engineering schools means that the agricultural land must give way not only to silicon, the iPhone, and dot-com farms, but also to housing.

The valley was initially linked to the outside by the railroads built around 1869, then by highways such as 101 and 85, and now by abundant fiber-optic cables and wireless routers. Despite rapid population growth bringing airports and wide freeways, Santa Clara County has retained its natural beauty. Abundant sun and fertile soil allow for high-margin crops. Today about 20,000 acres of farmland remain, mostly clustered around Coyote Valley, Morgan Hill, and Gilroy in the South County, as well as a small acreage of vineyards in the eastern Santa Cruz Mountains.

In 1921, some 75 railway cars were required to transport grapes from Gilroy depot to New York. Gilroy, "the Garlic Capital of the World," was also known for its abundance of strawberries. A tobacco capital and cigar-manufacturing center, the South County was also home to the invention of a process to preserve apricots and other dry fruit using sulfur. Many wineries are still thriving in the area today in spite of the closure of several larger ones. Mercury was extracted from the mines nearby to refine gold found in the Sierras. Sargent Station oil wells produced most of California's oil from 1866 until the discovery of other sources in 1880.

The famous buildings mentioned in the book include the Hayes Mansion, built in 1905. Designed by architect George Page, the 62-room mansion has been referred to as one of the finest examples of late-19th-century architecture in the Santa Clara Valley. The H. Morgan Hill residence was occupied briefly by the family who owned most of the county. Gilroy's old city hall, built in 1905 and featuring a combination of Nordic and Mediterranean styles, once housed the courtroom, clerk's office, and fire department. The 12 Mile, 15 Mile, 18 Mile, and 21 Mile Houses served as stops for stagecoaches en route to downtown San José.

Today the area is famous for its redwood trees and the variety of recreational activities on its man-made reservoirs. It is difficult to find another place as desirable as Santa Clara County. Many residents would agree this is their valley of paradise.

One

South San José, Coyote, and Madrone

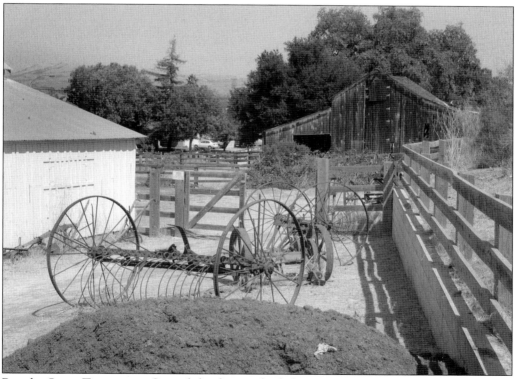

Rancho Santa Teresa was a Spanish land grant deeded to José Joaquin Bernal, a member of the Juan Bautista de Anza party of 1776. The ranch stayed in the family for several generations; tallow and hides were its main products. The Bernal family continued to operate the ranch until 1980. Santa Clara County and IBM acquired the remaining property near the end of Cottle Road. Several of the original buildings, including the four-room house and a barn, and some old farm implements can still be found on the property. See page 115 for a school document by one of the Bernals.

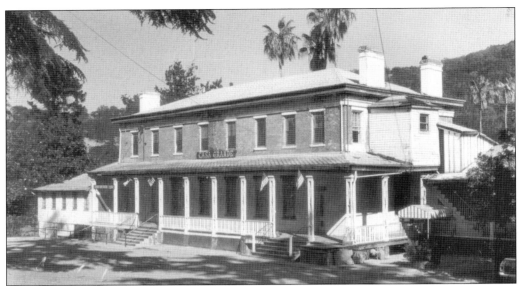

New Almaden rests in a canyon 11 miles south of San José, between the Pueblo Hills and the Santa Cruz Mountains. It began as a mercury mining town. Mercury, which was used to extract gold and silver, was especially valued during the Gold Rush days. The historic district includes the manager's residence, Casa Grande (constructed in 1854), and cottages used by company staff. Until 1920, Casa Grande was used as a personal and official residence with a five-acre garden. In the 1860s, a two-teacher school was built nearby. One of the oldest buildings in the district is an adobe house constructed in 1848. It later became the home of a busy man named George Carson, who served as the mine company bookkeeper as well as a postmaster, telegraph operator, and Wells Fargo agent. Pictured here are the front and back views of the building. (Courtesy of the Sourisseau Academy.)

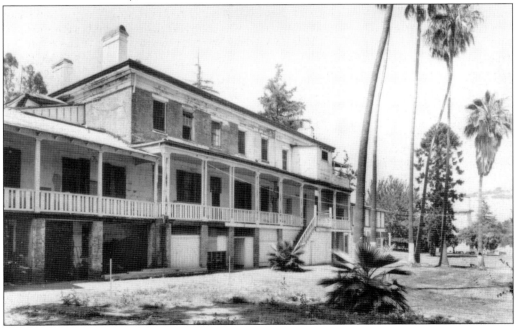

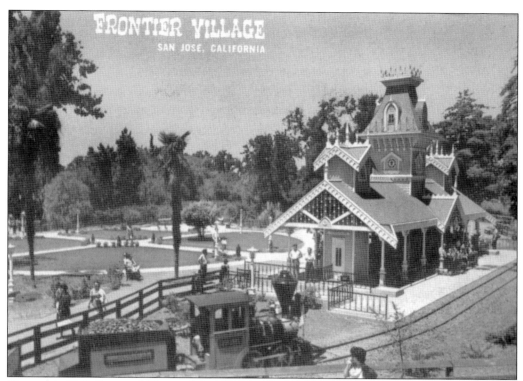

Opened in 1961, Frontier Village is located at the intersection of Monterey Highway and Branham Lane (near the original Eight Mile House). The result of a builder's fascination with Disneyland's Frontierland, the village was a popular western-themed amusement park for 20 years. The land was sold in 1980 to build condominiums. The fort is gone forever (below), and only traces of the entrance remain in Edenvale Garden Park. Frederick Tennant had purchased the land in the late 1800s and sold it to the Chenoweth family. In the 1920s, Judge William P. Lyon bought the land, planted apricots, and named it Eden Vale. Lyon's daughter later married into the Hayes family.

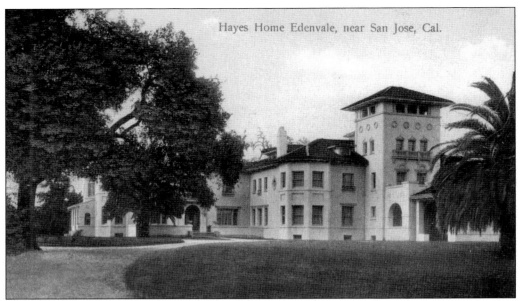

Hayes Home Edenvale, near San Jose, Cal.

Behind Frontier Village is the 62-room, 41,000-square-foot Hayes mansion built for the Hayes-Chenoweth family. The Hayes family first bought the land in 1887, and the house was completed in 1904. Designed by George Page, it was one of the finest Mediterranean villa–style homes in the area. The estate originally included many native oaks, and the owner added hundreds of eucalyptus, redwood, and pine trees. The trees remained on the land after Frontier Village was opened. The park was always shady and cool. The Hayes mansion has been restored and is now open to the public (pictured below). These tall eucalyptus trees are found in the middle of Monterey Road at the Blossom Hill Road exit.

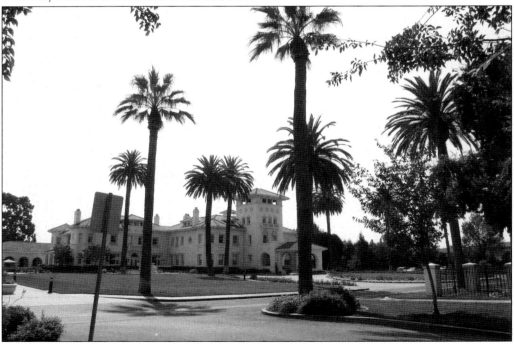

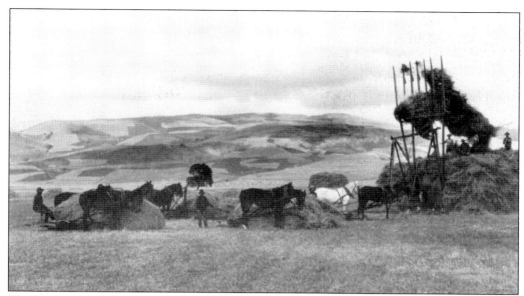

The legal costs of recovering 9,600 acres lost under the American jurisdiction forced the Bernal family to sell its land. An 820-acre parcel sold to Warren H. Cottle now adjoins Monterey and Snell Roads in San José. An 1876 Santa Clara atlas shows that the Cottles owned several parcels. They built a beautiful residence near El Camino Real in 1878 for $3,000. This 1890 hay-harvesting scene was captured close to their home. Sections on the hills were deliberately burned to enrich the soil.

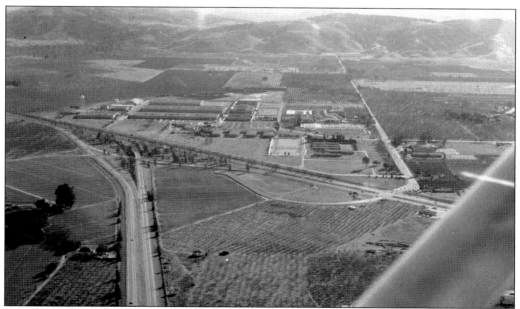

In 1956, IBM built a plant in San José, and soon disk drives with flying heads over giant spinning disks were invented there. This aerial photograph, taken by J. Zimmerman, shows the Cottle house and the old Downer School, just next to the airplane wing strut. The prune orchards around Downer (Blossom Hill) and Cottle Roads stretch as far as the eye can see. (Courtesy of J. Zimmerman.)

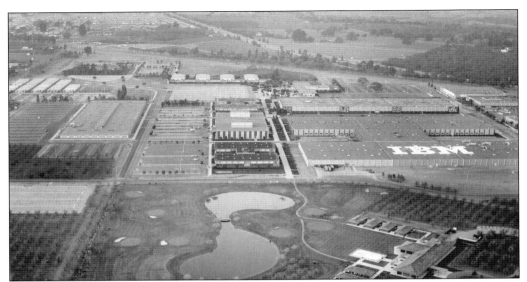

A closer aerial view reveals the IBM logo on the Building 6 roof. It became a San José landmark; people in airplanes knew they were approaching the south edge of the city when they saw the building. Note the water retention pond and the Homestead Golf Course, both inhabiting the site for 50 years. Most of the land is now being sold for housing developments. (Courtesy of J. Zimmerman.)

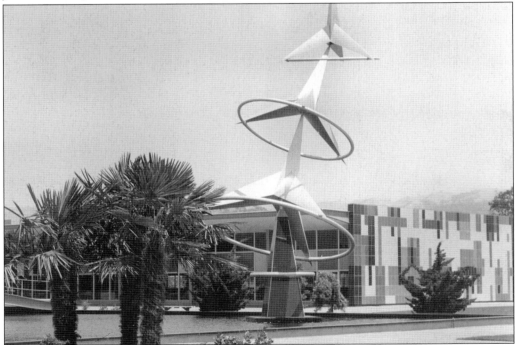

The IBM cafeteria, with its nearby pond and halo sculpture, was a centerpiece of the plant site. On windy days, the sculpture had to be secured with ropes. The cafeteria's good food impressed Nikita Khrushchev when he visited "a typical American factory" in 1959. He thought the quality food was a put-on to impress dignitaries. (Courtesy of J. Zimmerman.)

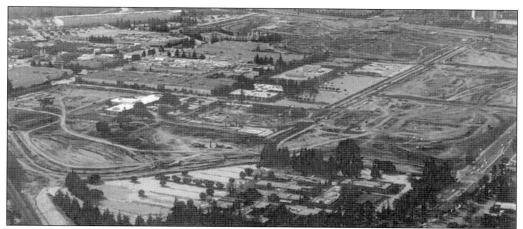

The high cost of producing disk drives forced IBM to sell the plant to a foreign manufacturer. This later aerial photograph reveals that many buildings were demolished. Monterey Road is on the left and Cottle Road on the right, with Highway 85 in the back. The current layout of the campus is similar to how it was 45 years ago. (Courtesy of J. Friedman.)

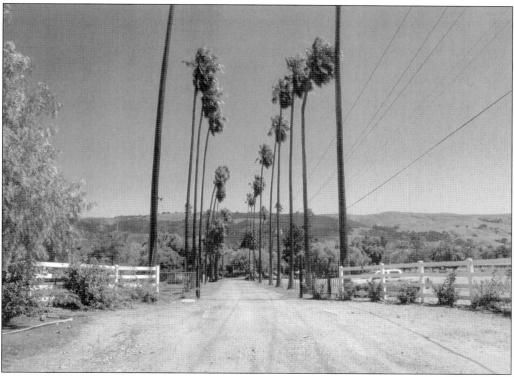

Coyote is off Monterey Road about two miles south of San José. Today it is known for its fishing spots, a shooting range, and Coyote Ranch, which is used for corporate gatherings and weddings. Capt. William Fisher purchased the 28,049-acre ranch in 1845 for $6,500. John Fremont and Kit Carson stayed there in 1846. Fisher's son built the impressive house, which still stands at the end of a driveway flanked by palm trees.

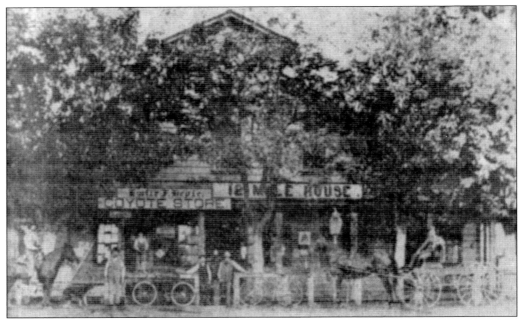

Built in the 1850s, 12 Mile House was a stop on the Butterfield Stage line between Monterey and San José. It was situated at the intersection of Monterey Road and the road leading to the Fisher ranch. In addition to serving the local population as a general store, the house had a 40-foot-long bar, a hotel upstairs, and a post office. Emile F. Heple owned 12 Mile House from 1890 to 1904. In 1963, a fire burned down the landmark. The post office section of the house is now in San José Historical Park.

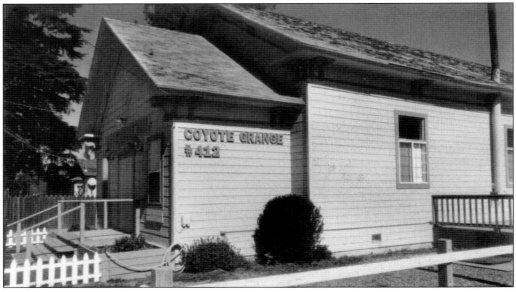

Just a block south along Monterey Road stands the Coyote Grange Hall, built by the Coyote Public Hall Association in 1892. More than a century later, it is still in use as a meeting place. Almost all the roadside fruit stands are now defunct and crumbling, as Highway 101 was moved farther east in 1985.

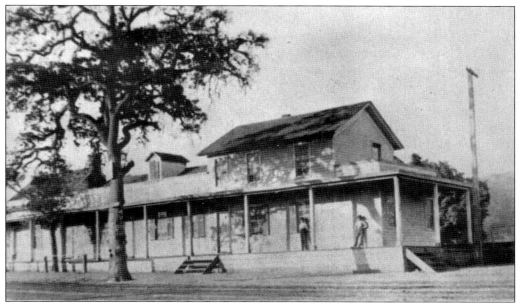

Madrone, which predates the city of Morgan Hill by about 50 years, was originally on the west side of Monterey Road. After the construction of the Southern Pacific Railroad blocked all the back exits, the town moved to the east side. Madrone consisted of several shops and a hotel known as the 18 Mile House, as it was that far from downtown San José. This photograph was taken around 1899. The area was annexed by the city of Morgan Hill in 1958.

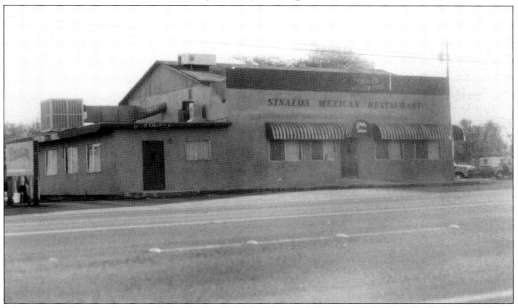

Many years later, what was left of the 18 Mile House (Madrone Hotel), which had held the Butterfield Overland Stage stop and the Pinard Saloon, was converted to the Sinaloa Mexican Restaurant. On Friday evenings and on weekends, it was crowded with workers enjoying a margarita and a good meal. The restaurant burned down in the late 1990s, and the owner vowed to rebuild it someday.

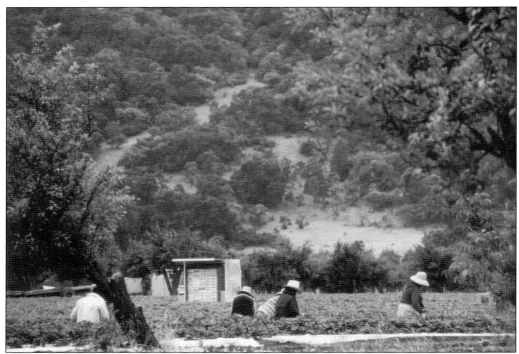

This strawberry farm was situated on the west side of Hale Avenue. Many still recall cars parked more than a mile down the road as people came to pick up flats of strawberries for Memorial Day picnics. This photograph, taken by C. Dasilva, shows the farm and its diligent workers. The fruit was sold from a shack under a giant oak tree. Today only an empty field remains (pictured below).

The giant oak tree finally fell down, and the strawberry farm and stand are now closed. A poem is carved on a section of the tree that has been preserved: "From a tiny acorn to a towering giant. It stood proudly for many centuries. . . . Like all living things it has to go. For that oak tree we all thank you. Year 1672–1994."

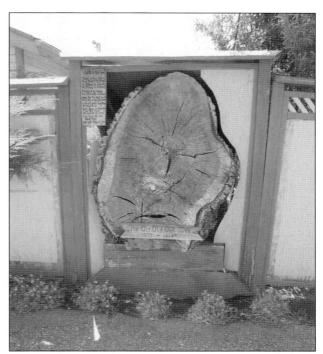

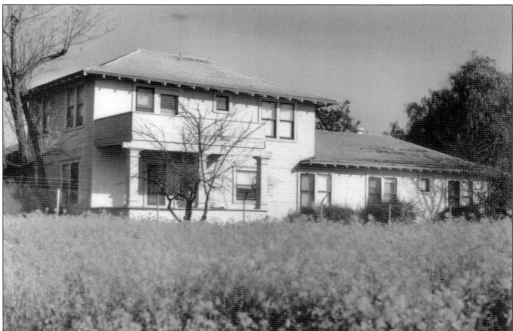

The 1876 Thompson and West Atlas identifies this building at Palm and Monterey as Perry's railroad stop. According to Charlene Duval's research, the house was rebuilt after the 1906 earthquake. There are several "15 miles" signs on crumbling buildings nearby, confusing most people. The Madrone district included Peebles Avenue, with 190 Peebles serving as the village jail. Most of the original homes were demolished to allow for modern estates. Little history was documented.

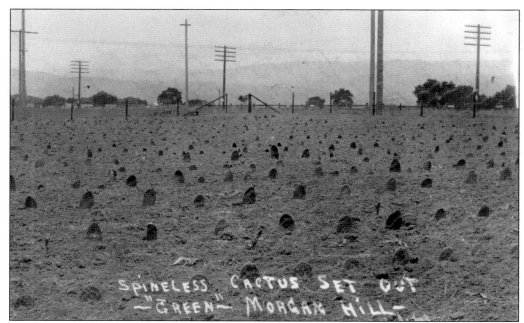

Luther Burbank of Santa Rosa worked to develop a spineless cactus. These plants are actually very easy to grow; one needs only to bury one-third of the "pad" in well-drained soil. Morgan Hill was the ideal place for growing spineless cacti, as it is sunny and water is available from streams and groundwater. This *c.* 1910 photograph was taken east of Monterey Highway just south of the 15 Mile House, facing Tulare Hill in Coyote.

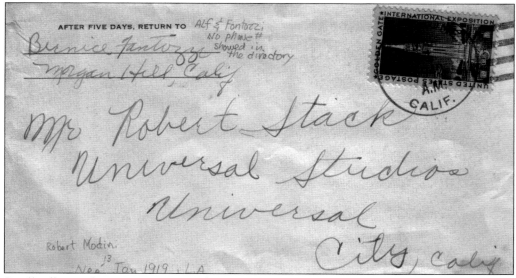

Small villages often experience postal station closings. The Sherman postal station opened on December 13, 1867, and was closed three years later. Not long after that, it reopened for 11 years, and the name was changed to Madrone in 1882. The post office moved to Morgan Hill in 1959, after the area was annexed. This postal cover was mailed out in 1940. Bernice Fontozzi, then a teenager, sent a letter to actor Robert Stack at Universal Studios.

Two

MORGAN HILL

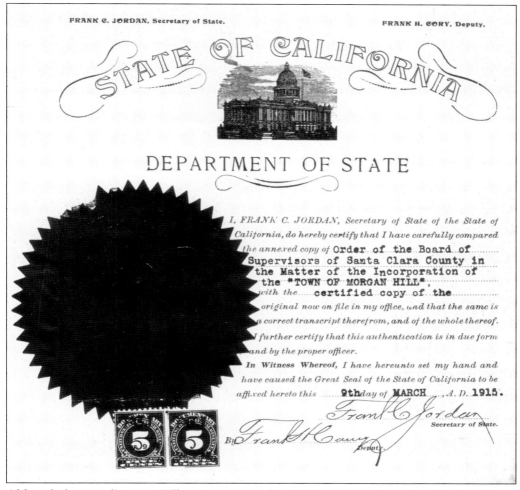

Although the city of Morgan Hill was incorporated in 1906, secretary of state Frank Jordan did not pronounce it a legitimate city until 1915. The document tax was only 10¢ back then. (Courtesy of the Morgan Hill Historical Society.)

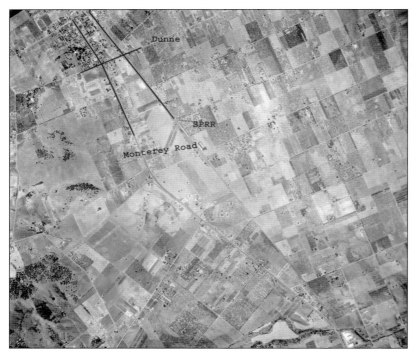

This 1956 USDA aerial view of the town shows, from left to right, the Live Oak High School track, El Toro, Southern Pacific Railroad tracks, landing strip, and Dunne and Monterey Roads. The major roads were well laid out years before, making planning and surveying relatively easy. Orchards and clusters of live oak trees dotted the hills. (Courtesy of the Santa Clara County Archives.)

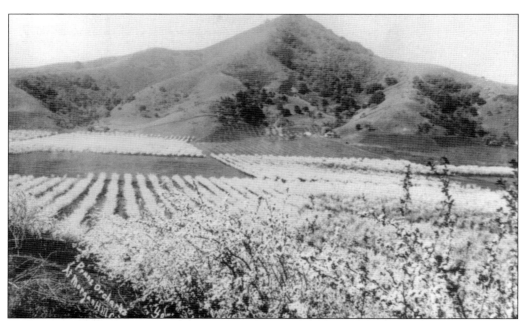

The Morgan Hill area is positioned in the West Valley, in the shadow of a distinguished 800-foot peak called El Toro. Earlier settlers cut the live oak trees in order to plant prune and other fruit trees. The entire South Santa Clara County was covered with spectacular blooms in the spring, making the area known as "the Valley of the Heart's Delight." This 1907 postcard reveals a lost view of Dunne Avenue, as most of the orchard has now given way to housing and commercial use.

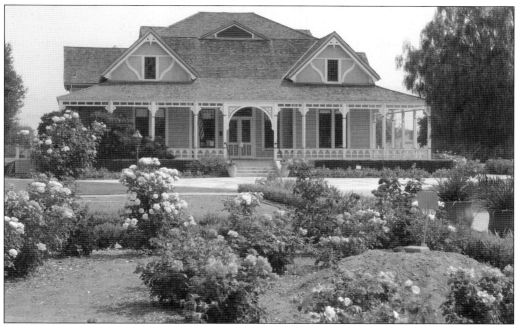

In 1886, Villa Mira Monte was built in the Queen Anne style as a summer home for H. Morgan and Diana Murphy Hill. Surrounded by orchards and ranch buildings, it offered a view of El Toro Mountain. It was occupied by several families before becoming an antique store in the 1970s. The house was restored by members of the local historical society. Today Villa Mira Monte, also known as the Morgan House, has a new neighbor: the John Acton House (pictured below).

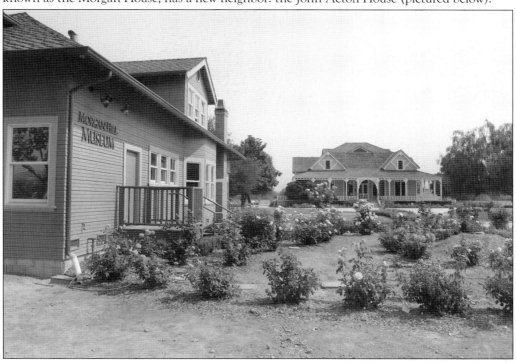

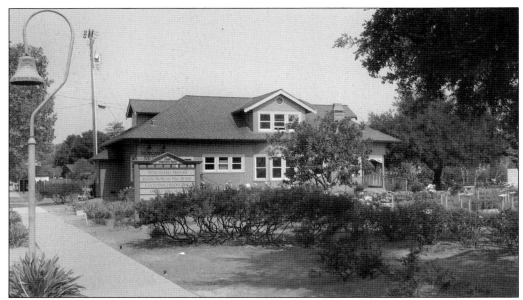

The Acton House stood off Del Monte Avenue at 170 Warren for 50 years. It was built in 1911 at a cost of $2,700 and was later donated to the local historical society. After restoration by volunteers, the house was recently relocated adjacent to Villa Mira Monte on Monterey Road. Next to the house is a historical marker of a Franciscan walking stick with a bell; this type of symbol was first erected in the 1920s by the American Automobile Association to commemorate Spanish missions from San Diego to Solano County.

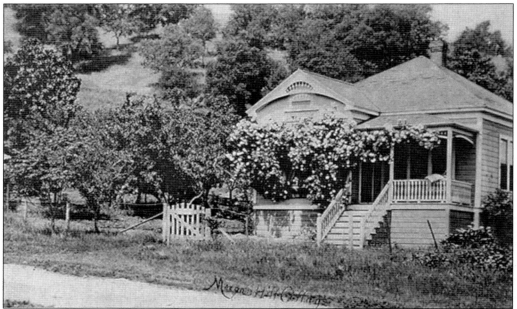

Juan Hernandez and Martin Murphy, who at one time owned the entire area, lived in an adobe house at Murphy's spring off Llagas Avenue. Half a mile south was Wright Avenue, the northern boundary of El Toro. This photograph was used in a 1901 postcard. The climbing roses planted in front of the house were popular at the time. Most homes along the avenue have since been rebuilt.

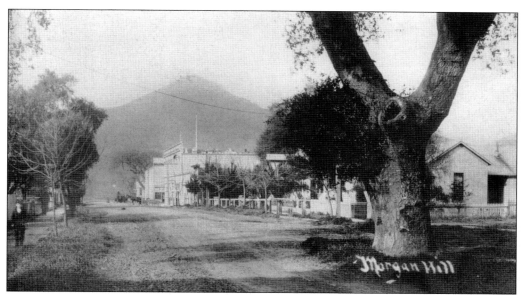

Downtown Morgan Hill used to encompass a few blocks from Main to Fourth Streets (Nob Hill Avenue) along Monterey Road. This view, dated around 1920, was taken from Second Street looking west. It shows El Toro, the 1905 Votaw Building, and the Bank of Morgan Hill (later the Bank of Italy). The building now houses Caffee Kaffee Vin. Gone are the horses and buggies that were once used for transportation. Below, automobiles are now parked along the street. Instead of Leo Tonascia, the famous motorcycle officer of the 1950s, issuing endless citations for speeding, the police today cite drivers for failing to attach the baby seat belt.

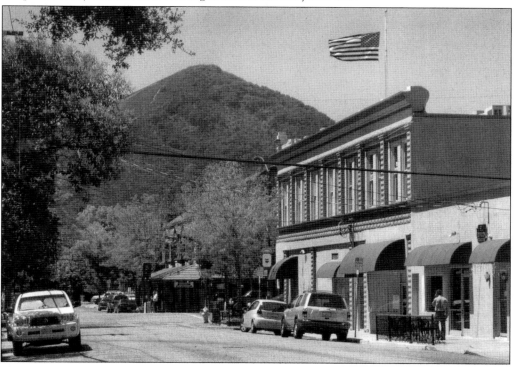

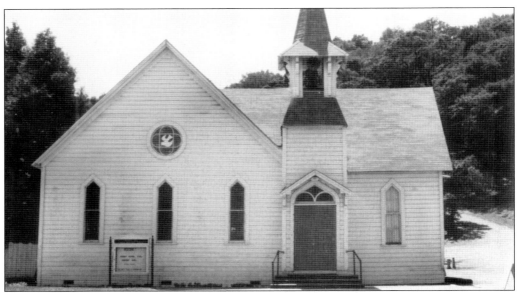

Just two blocks north of Dunne Avenue on Monterey Road stood a Victorian Gothic Methodist church. It remains in use and looks much as it did in 1893. The building served as a joint Baptist and Methodist church and also as a temporary school when the town had no such facility. The parsonage, now the annex, began construction in 1895. The structure still has a molded tin ceiling and the white clapboard look typical of many buildings of the era. The church displays many artifacts and Baptist records.

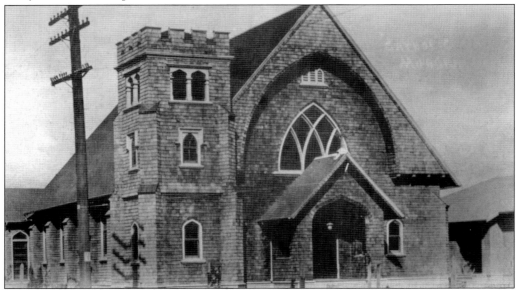

Prior to 1884, Catholics had no place to worship between San José and Gilroy. Sacred Heart Church was established in Madrone, which was then the center of population. Twice a month for 25 years, a priest came down from San José by horse and buggy. A church was finally constructed at the corner of El Camino Real and East Dunne in 1909 at a cost of $10,500. Over the next 50 years, the parish grew from 150 to 2,400. Much of the church's historical material is now housed inside the present St. Catherine's on Peak Avenue.

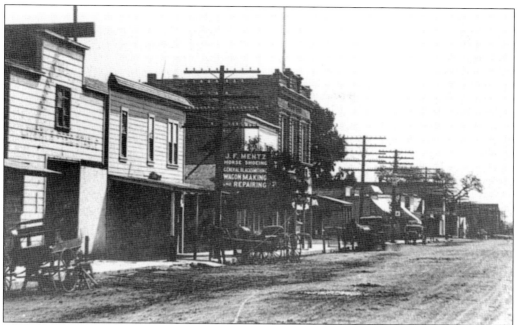

The days of seeing horse-drawn wagons and hitched horses in front of the Bank of Morgan Hill are gone. Above, to the left of the Votaw Building stood Mentz's blacksmith shop, where horseshoes were replaced and wagons repaired. In 1924, the blacksmith was replaced by the Granada Theater, which brought silent movies to the small town. The theater has been closed since 2004, and the city just bought the property. The old Bank of Italy became a coffeehouse.

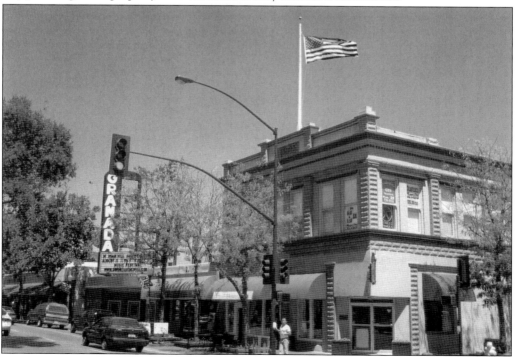

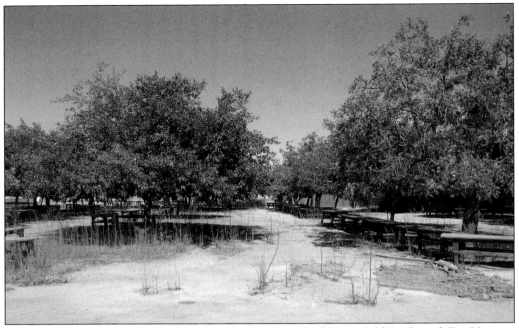

The flea market was situated at the intersection of Main and Butterfield Boulevard. For 30 years, it was a pleasant place to spend a Saturday or Sunday looking at merchandise and listening to Mexican music. The site is deserted today, although the planned Huntington Square development (named after the old depot) will comprise 134 condominium units nearby.

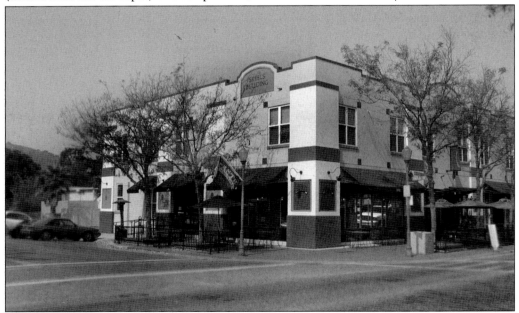

Around 1910, Henry and Harry Skeels built a hotel with a restaurant and bar. Constable Lloyd Skeels used the hotel as his office. The facility's most famous guests were Swedish crown prince Gustav Adolph and princess Louise, who stayed one night in 1926 to dedicate Sveadal, a summer resort in Uvas Canyon.

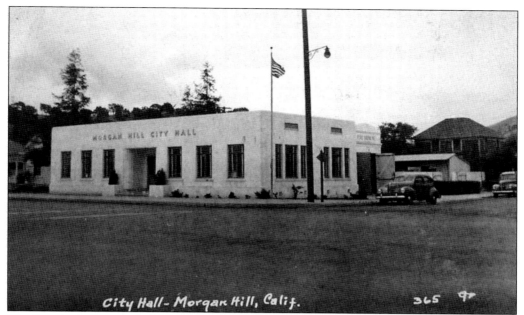

City Hall - Morgan Hill, Calif. 365 9P

The first city hall was a shed-like wooden structure with a fire bell and a tiny jail in the back. The next facility was built at the corner of Main Avenue and Monterey Road in 1930. (The building is occupied by Wamu Bank today.) A. W. Story designed the hall, which was then built of concrete, tile, and bricks by Johnson Construction for under $7,950. In 1958, when the police and fire departments both moved in, the structure had to be enlarged. In 1974, it was relocated to Peak Avenue. This city hall had an Oriental appearance and a pond, as the architect was Asian.

Morgan Hill's Grange No. 408 was completed in the mission style in 1907. Constructed of concrete and stone blocks, it had two stories and a basement. This grange was the only one in the area that had its own hall. The grange was once the hub of a rural community, its purpose being to teach better farming methods. The Grange Hall has been restored and remains in use.

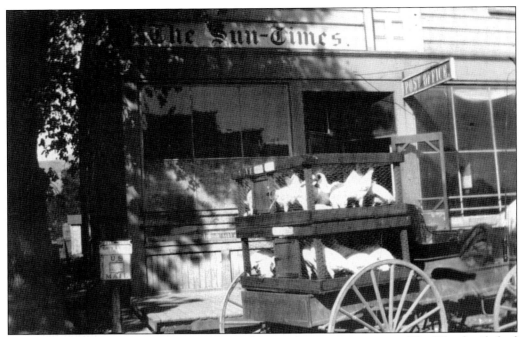

In 1894, George Edes founded the *Morgan Hill Sun*, a four-page newspaper. The Edes family had been journalists since Revolutionary days. Edes got started by providing free advertising for a developer in exchange for a plot of land. He also served as postmaster. In 1902, the *Sun* merged with the *Morgan Hill Times*, becoming the *Sun-Times*. In its 103-year history, the paper changed ownership no less than 16 times. It provided a vital community link and offered glimpses of the past. The newspaper stood at the same address for more than 75 years. History tends to repeat itself; the old photograph above shows a poultry wagon parked in front of 30 East Third Street, and the current office below shares a building with the fish and poultry store.

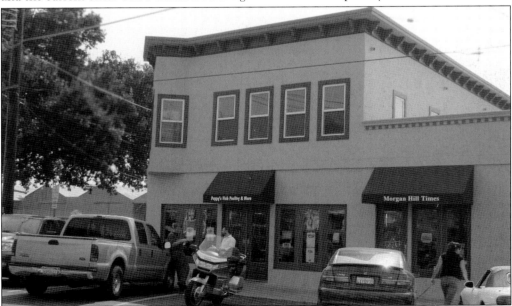

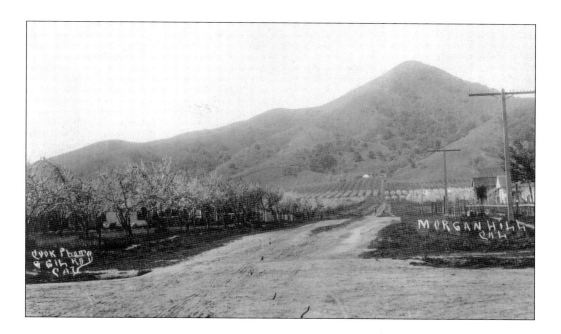

El Toro (Murphy's Peak) has been the center of much controversy and discussion regarding commercializing the peak and adding a cable car to promote tourism. Many local adults recall "Save El Toro!" as an environmental slogan from the early 1970s. In downtown Morgan Hill, little evidence remains of the original orchards. Three-dimensional mapping has confirmed that the first photograph was taken at the intersection of Dunne and Monterey. The photograph below shows the profuse blooms of the prune orchard in early spring.

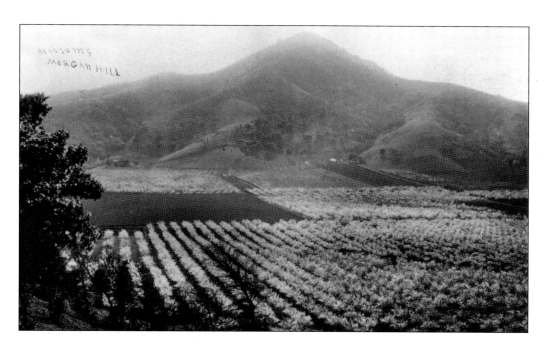

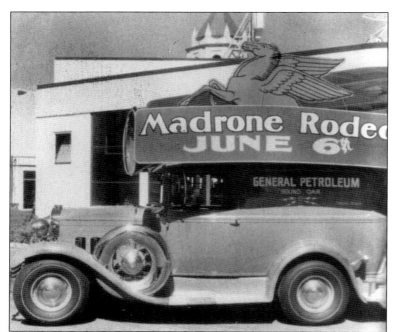

Madrone was the center of the city in the 19th century. During the Mexican days, people trapped bears in the mountains and made them fight with a bull in a ring. In 1934, local ranchers formed the Madrone Rodeo Association. Every year until 1941, professional rodeos were held in early summer at the J. W. Sheldon Ranch on Hale Avenue. The vehicle shown here was used to promote the event.

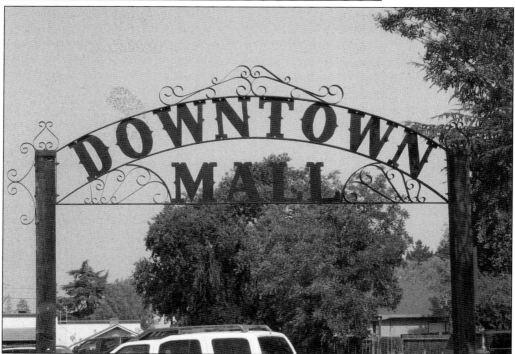

The city council is determined to keep the downtown area active and nostalgic. The Farmer's Union Cooperative, built by John Gals in 1922, became the Downtown Mall, which looks deserted today with only one tenant. The city has retained its friendly, small-town atmosphere. Outdoor concerts used to take place here in the summer, and starting in 2007, the annual Mushroom Mardi Gras is held in the downtown streets.

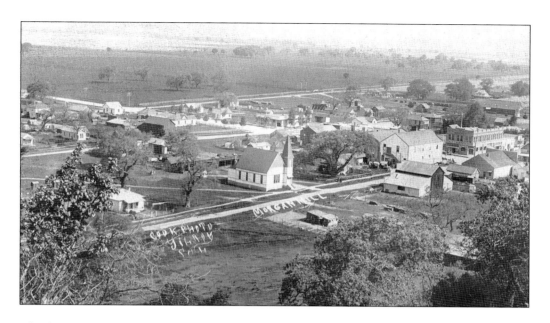

This bird's-eye view of the newly incorporated city of Morgan Hill was taken from Nob Hill sometime before 1908. Note the complete absence of automobiles; only horses are seen next to the Skeels building. The city later added a water storage tank. A photograph taken from the same vantage point about 70 years later shows rows and rows of houses, trees, and cars. The overgrown tree shrubs are blocking the left side view and are tilted more to the right. The Votaw Building (lower right) is the only structure that looks the same in both images. The others have all been rebuilt to look radically different.

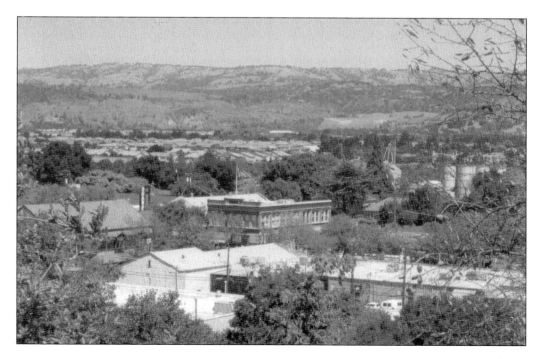

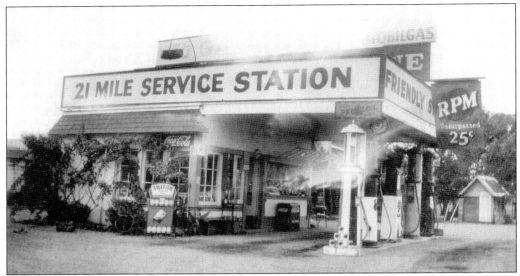

Prior to 1879, there were a number of stage stops between downtown San José and Gilroy. The 21 Mile House was one of these. Today it is the Vineyard Town. William Tennant built the two-story house, which later became an automotive service station owned first by the Casella family and then by Lewis Donner from 1920 to 1936. Lewis's son Doug Donner is well known to many as a household appliance repairman.

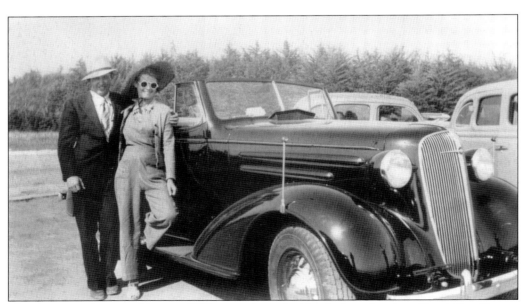

The Gunters, who moved here in 1927, not only worked hard; they also played hard. Roy Gunter sits with his friend Vivien Rudd in a flashy new 1937 Chevy convertible. Vivien later married one of the Gunters, but not Roy. (Courtesy of E. Gunther.)

Three

East of the
Santa Cruz Mountains

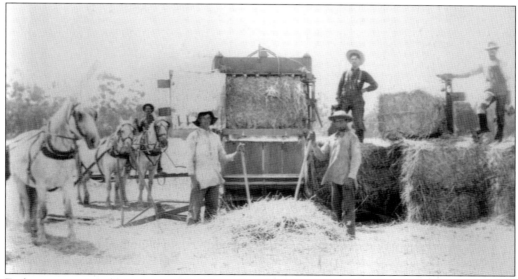

Early crop-cutting devices resembled those found on reapers and binders; from these came the modern array of fully mechanical mowers, crushers, field choppers, balers, and machines for palletizing. The hay press became popular during the 1870s. Two horses pulled the power unit along the sides of the press while two men used crowbars to manually maneuver the press into action. The hay baler was now ready for a complicated motion, and the bale was bound by five wires. Each bale weighed 250 to 300 pounds. This photograph was taken in the Uvas Valley.

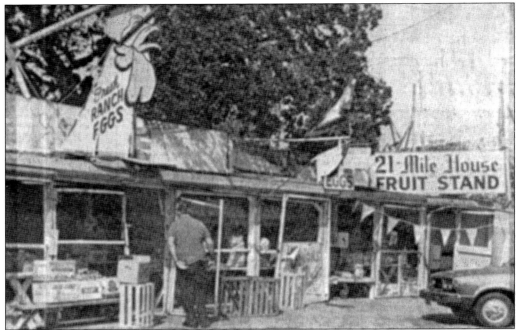

Between 1936 and 1976, the 21 Mile House Fruit Stand was owned by several families. The rerouting of Highway 101 west of the railroad in 1972 reduced business significantly, and the stand was eventually closed. The Kant groups developed the shopping center and created a park by the remaining live oak trees. All that is left today is a commemorative plaque at the corner of Monterey Road and Tennant Station, as pictured below.

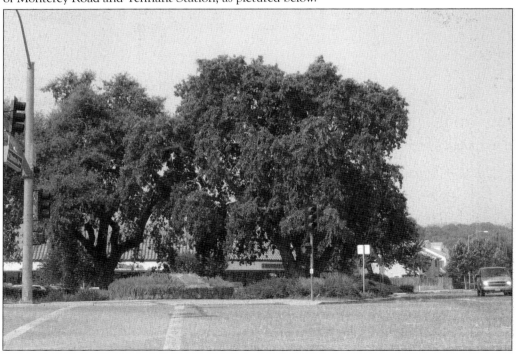

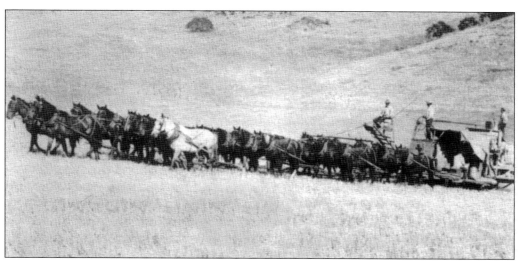

The combine, a harvester-thresher combination, was introduced in the 1840s and later used in California. The product was grain, and the by-product was loose straw. Getting 32 horses to pull in sync while working on a complicated process was not a trivial task. The author helped develop the hydraulic, diesel-powered, tilled hillside combine early in his career. Pictured here is a horse-drawn combine used in the South County in 1882.

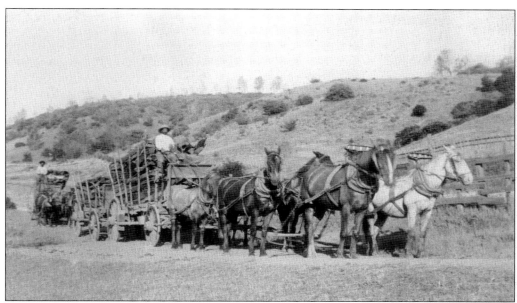

Redwood timber was cut from the area and shipped to Quick Silver Mines as supports for buildings and mercury mine tunnels. In this photograph, two horse-drawn wagons make their way to the Almaden Valley on present-day McKeon Road. The driver of the first wagon is Ignacio Sepeda. The bells on the horses warned of an approaching wagon. (Courtesy of Delores Sepeda.)

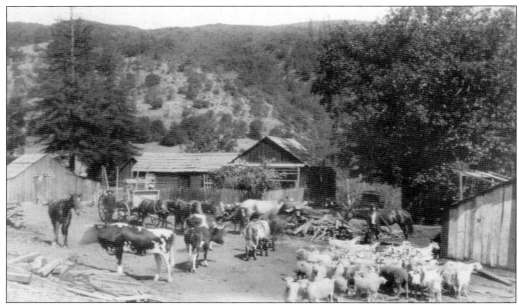

Uvas residents had to be resourceful to survive. They generally worked together as a team. In addition to raising cattle and sheep and growing non-irrigated grapes and hay, they cut and sold wood. The J. Montoya residence, located off Croy Road, is shown in the second decade of the 20th century. (Courtesy of Delores Sepeda.)

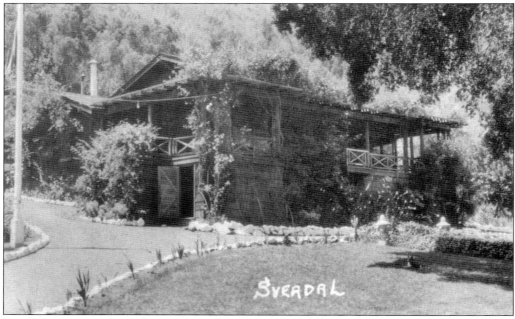

Sveadal, a private Swedish American resort, was established on the site of the Martinholm summer boardinghouse in 1926. It is situated near the end of Croy Road, a few miles southwest of Morgan Hill. The opening of Sveadal was a memorial event in the South County. The crown prince and princess of Sweden presided at the opening, and the mayor presented the royal pair with a basket of prunes. Sveadal is still restricted to members only.

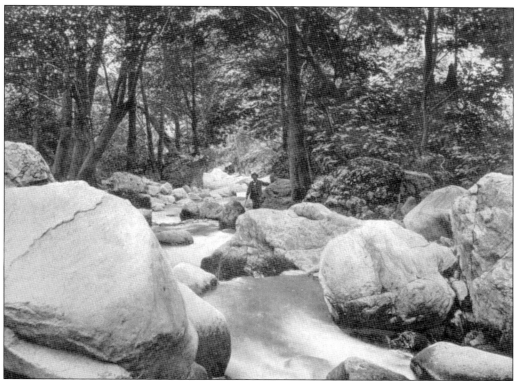

Uvas Canyon is situated on the east side of the Santa Cruz Mountains. Getting there by car today is as much an adventure as hiking the trails on foot. The nearby Rancho Las Uvas, which included most of the Uvas and Llagas Creeks, was granted to Lorenzo Piñeda in 1842 by the Mexican government. The Uvas area was named for the wild grapes that once grew in abundance. Uvas Creek features several small perennial waterfalls, as shown in this 1910 photograph below.

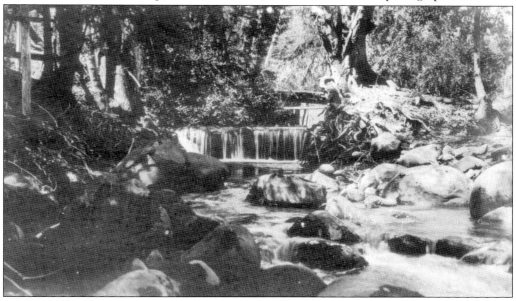

Fanny Stevenson, Robert Louis Stevenson's widow, owned 120 acres of land called Vanumanutagi. The name is Samoan for "Vale of the Singing Birds." Fanny built an English-style lodge and enjoyed entertaining on her poolside deck (pictured below). The 1901 house remains; current owner Leo Ware planted vines in 1981, and the property and vines are meticulously maintained. The family sells Vanumanutagi chardonnay wines that carry romantic names like Treasure Island and Jekyll and Hyde.

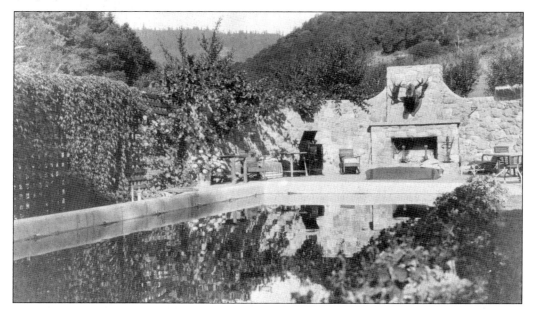

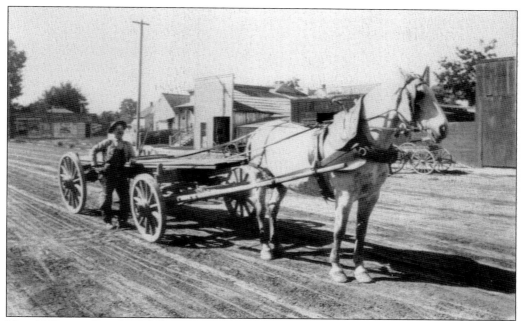

Uvas Valley residents traveled to nearby towns to sell or procure merchandise. Here J. Sepeda uses his horse and wagon to run errands near Morgan Hill. Residents often had to depend on their neighbors to do their shopping for them in San José or Morgan Hill, as the trip took an entire day. Eventually the valley had two general stores.

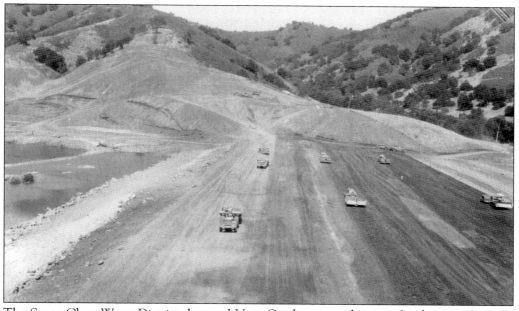

The Santa Clara Water District dammed Uvas Creek to provide water for the area. In 1957, Gilroy civic leader Dr. Elmer J. Chesbro commissioned the Uvas Reservoir, which is shown here in its construction phase. The Uvas Dam and Reservoir are built two miles upstream from the intersection of Watsonville and Uvas Roads. The reservoir's capacity is 9,835 acre-feet; the overflow water is used to replenish groundwater pumpage.

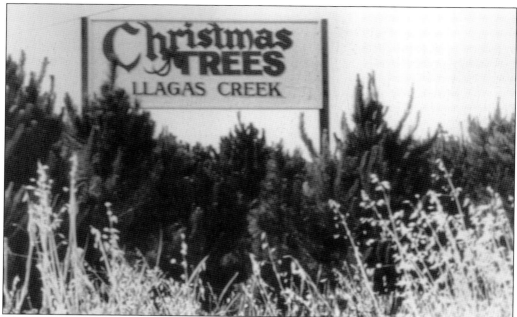

The original Machado House, at 14905 Santa Teresa Boulevard, became Llagas Christmas Tree Farm. Many remember coming to the farm to enjoy the fresh air and select their favorite live trees for Christmas. An old house and the tall redwood tree planted by Mary Murphy in 1874 are all that remain of historical interest. The Machado House is also the approximate location of an overnight stay by the 1775–1776 De Anza expedition team en route to San Francisco.

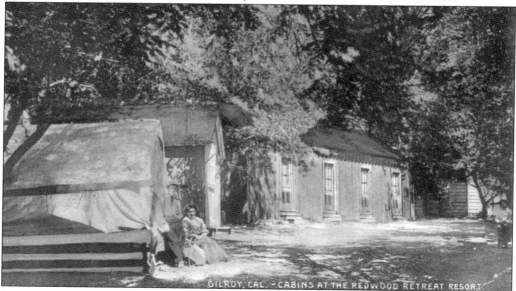

In 1863, Charles Sanders came to the area for his wife's health and received 400 acres of homestead in the Santa Cruz foothills. Sanders opened a resort lodge and planted a vineyard, which the family operated from 1891 until 1931, when it was closed for economic reasons. This 1918 photograph shows a group of cabins on the property. Today the land still belongs to the family; Charles Sanders's fifth-generation descendants are trying their hands at winemaking.

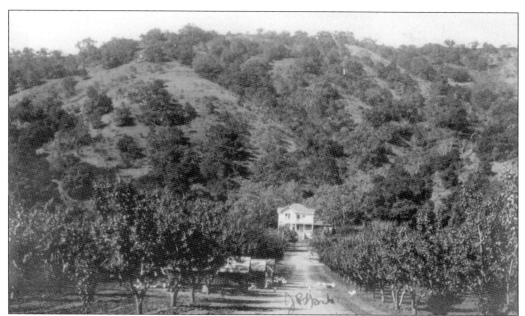

Paradise Valley lies southwest of Morgan Hill. The Ward family arrived here from South Dakota in 1894. The Wards bought 75 acres from the Dunne tract, cleared the land, and grew peaches, plums, and then walnuts. The family still occupies the 1910 residence, a large three-story farmhouse near Oak Glen Avenue. Retiree Paul Ward runs his tractor to stay active. At right, a San Martin School student poses in front of the 1894 Ward Ranch entrance.

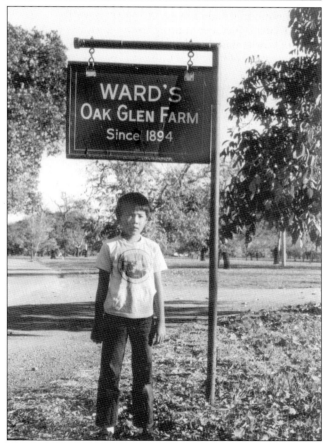

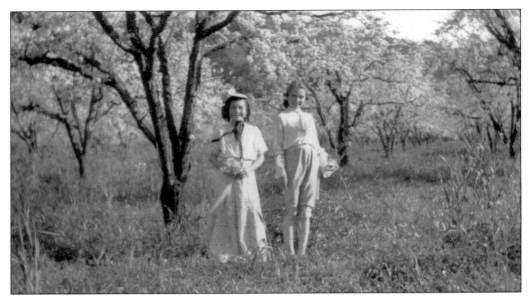

Wilma Ward (left) is pictured with neighbor Katherine Stone at her family's Paradise Valley farm in the spring of 1938. Spectacular fruit blossoms made people believe they were in paradise. The Ward home, standing as a reminder of life in the early 20th century, is decorated with family memorabilia. The house served as the setting of *Kiss Shot*, a 1989 movie starring Whoopie Goldberg. (Courtesy of Paul Ward.)

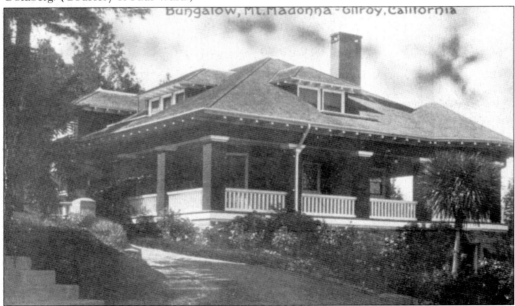

Between 1860 and 1870, Henry Miller bought and leased land throughout the West. He ultimately had more than one million cattle and 100,000 sheep on nearly two million acres, and much of the Santa Clara and San Joaquin Valleys came under his control. Miller's summer home, Mount Madonna, cost $125,000 to build in 1901; it had seven bedrooms and 3,600 square feet of ballroom. Today only a few foundations and sections of stone wall are left. Barbecues at the guest tents were a weekend tradition for Miller and his family and friends.

Four

GILROY AND PACHECO PASS

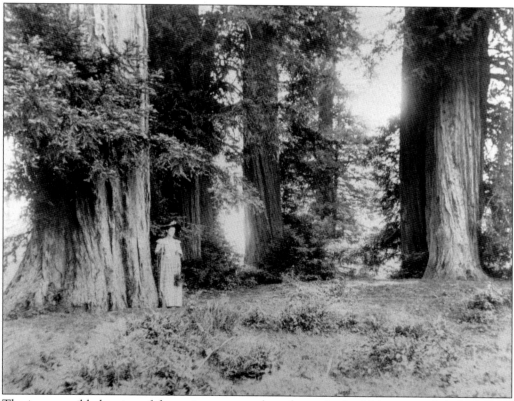

The irresponsible logging of these giant coast redwood trees in the 19th century left the Mount Madonna area with only four ancient trees. These were once found in abundance from the Oregon coast to south of Santa Clara County. The logging stopped after the 1906 earthquake, and the county turned the resort and 3,219 acres of land into a park. At 1,857 feet, Mount Madonna's lodge provides spectacular views in several different directions.

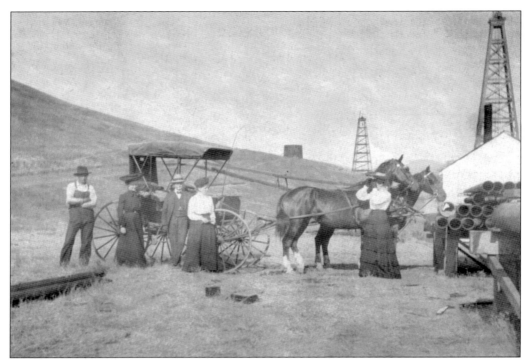

Sargent is situated on Highway 101, just south of Gilroy and west of the Southern Pacific Railroad. Used as a train stop, it was named after landowner John Sargent. The first California oil wells were located here in the 19th century. Shown in the upper photograph are Winfred Fitzgerald (overalls), Lawrence Cutler (suit), and three unidentified woman. (Courtesy of the Gilroy Museum.)

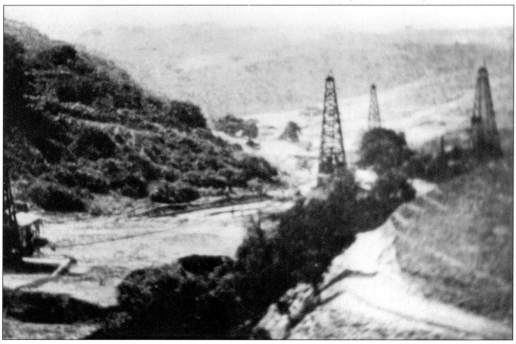

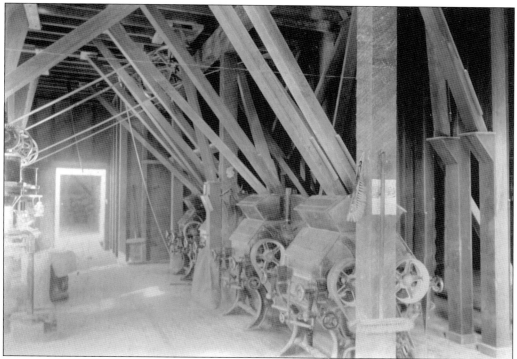

Gilroy pioneer John M. Browne owned Santa Clara Flour Mills. In the 1870 census, he declared that he owned real estate worth $70,000 and personal property worth $36,000. The Bernal and Hellyer families, who were engaged in agricultural operations and had huge tracks of land, each declared a net worth of merely $7,000. In spite of his early success, Browne died in San Francisco in 1895 as a pauper. His house in Gilroy, pictured below, still stands today.

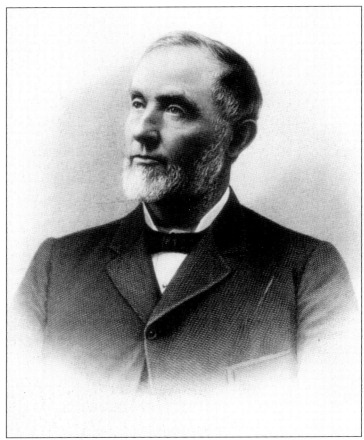

Henry Miller came to San Francisco during the Gold Rush with only $6. A butcher with business sense, he later moved to the South County to acquire land and cattle. The headquarters for cattle baron Henry Miller was a self-supporting village near the Pajaro River and Highway 101. By 1883, Miller and his partner, Charles Lux, had amassed more than one million acres of land and an equal number of cattle. They owned most of the water rights for the rest of the state and part of Oregon. The main building was located just south of Gilroy at Monterey Road and Bloomfield Avenue until burning to the ground in 1923. A fair businessman, Miller also owned a weekend getaway home in Mount Madonna Park.

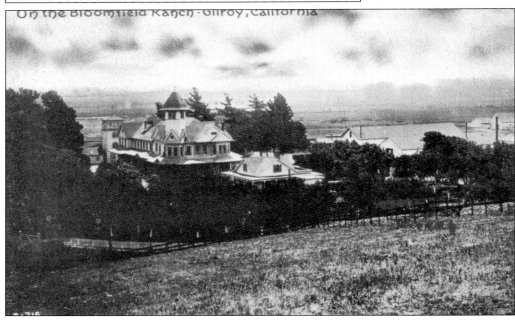

On the Bloomfield Ranch - Gilroy, California

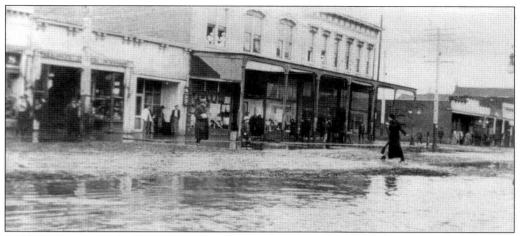

In 1905, the county had a wet winter. Almost 19 inches of rain fell from December through March, and water accumulated on Monterey Road because Gilroy did not have a storm water drainage system. Apparently it was business as usual, as many people were sitting around the store entrance in the picture above. The winter of 1914 was even wetter, with 28.79 inches of precipitation flooding the downtown and countryside alike. Boats were used for transportation in submerged areas. Because of frequent winter flooding and summer droughts, farmers and business leaders formed a water conservation committee in the 1920s. A consultant named Tibbetts recommended the construction of a series of 17 large reservoirs to capture rainfall and replenish the underground aquifer artificially. Today the reservoirs and charging aquifers are controlled by the water district.

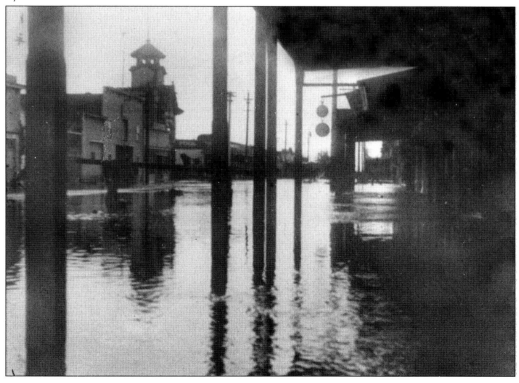

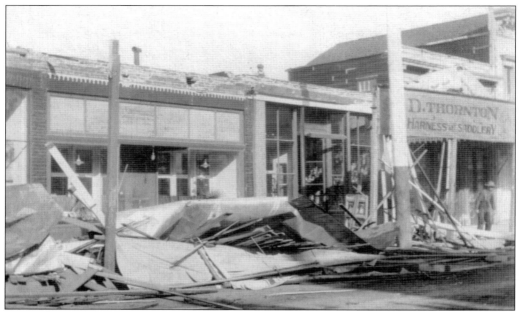

The powerful 1906 earthquake would have registered at an estimated 7.2 on the Richter scale. The Gilroy City Hall, under construction at the time, suffered only moderate damage, but many brick structures collapsed. The event occurred in the early morning and roused people from bed. Damage, including this in the downtown area, was estimated at $50,000. According to the *Gilroy Gazette*, however, the earthquake did not cause any loss of life.

Dr. James Thayer and Dr. Jonas Clark's hospital was located at Monterey and Fifth Street. A number of historical photographs show nurses watching floods or parades from upstairs windows. During the 1906 earthquake, the hospital walls were pulled apart, causing an emergency evacuation of surgery patients. Business went on as usual; doctors just worked outdoors.

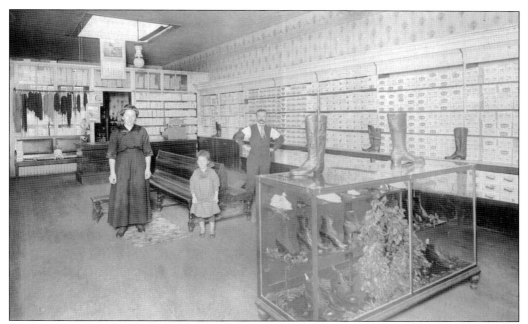

In the late 19th century, the Besson Shoe store exhibited fashionable cowboy boots and ladies' pointed-toe high heels. According to a 1913 telephone directory advertisement, August Besson's store, located at Seventh Street and Monterey Road, was the home of good shoes. In 1895, the ladies' razor-toe boots shown here were selling for $2.50 to $2.75 a pair. The ranchmen's Montana boots fetched $3.25. A Yatisi corset was 85¢. Gold was selling for $20.67 per ounce.

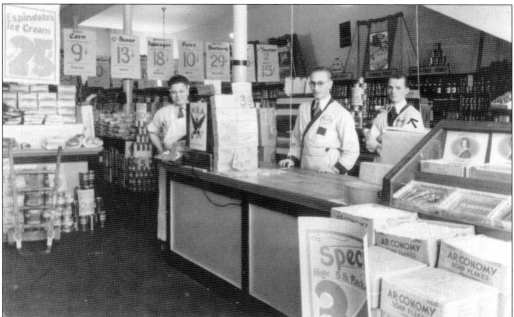

Locally grown food was plentiful, as indicated by the low prices at J. G. Wilson's store. In 1930, corn cost 9¢, beans 12¢, and shortening 29¢. The price of gold was still $20.67 per ounce. (Courtesy of the Gilroy Museum.)

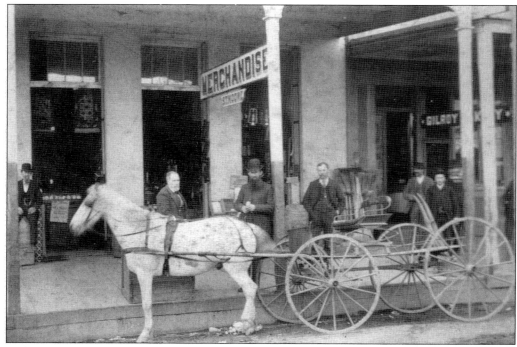

Samuel T. Moore was a multi-career businessman. A rancher among other things, he owned a general merchandise store at Sixth Street and Monterey Road in the late 1880s. His nice two-story residence on Church Street is still in existence. (Courtesy of the Gilroy Museum.)

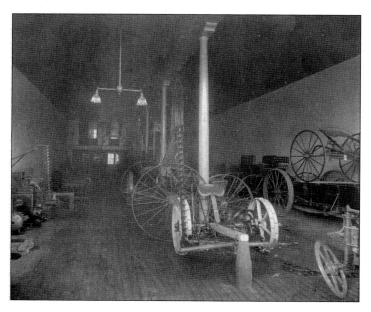

The farm implements sold at the Robinson building were composed mostly of oak wood and cast iron. The hay tender with forks weighed 400 pounds and sold for about $30. The rake with big steel wheels and 24 teeth weighed 275 pounds and sold for $17. Electricity was already available, so one could use a lathe and machine-customized parts. Note the locked lever rake standing upright next to the machinery. This business seemed to manufacture buggies also, costing the buyer $50 to $75.

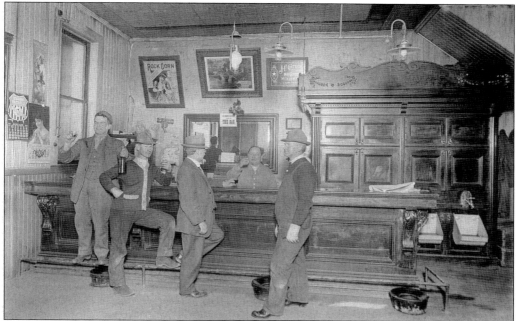

Battista Tognalda operated a saloon at 7529 Monterey Road, and his family lived upstairs. The saloon's unique sinks are shown on the right side of this photograph. Under the bar are apparently three spittoons. Beginning in 1920 and for the next 55 years, the building was leased to the Leedo Gallery, in which six different drugstores operated. Gilroy, with many saloons and fights, was certainly not a dry town.

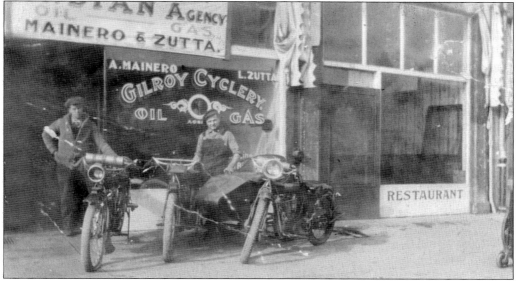

In the 1920s, Harley-Davidson was the world's largest motorcycle manufacturer, with more than 2,000 dealers in 67 countries. These appear to be 1922 models, which had about 64 cubic inches of displacement and were capable of traveling at 65 to 100 miles per hour. One of the bikes includes a passenger sidecar. This photograph was taken in front of the Minero and Zutta Gilroy motorcycle shop.

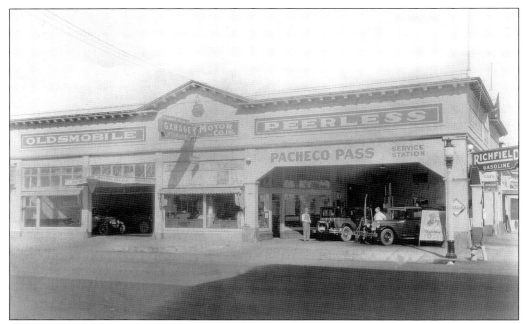

Oldsmobile vehicles are serviced under a Peerless sign at Pacheco Pass Garage in 1929. Unlike Ford, which targeted the general market, Peerless was a reliable, high-precision, deluxe car with a life expectancy of 10 years or more. Unfortunately, Peerless's automobile operations were discontinued in 1934, and very few of the vehicles have survived. Now that American life is centered on cars, one can appreciate how much service stations have changed.

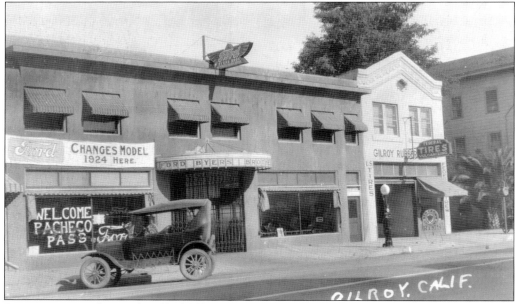

Between 1908 and 1927, the affordable Ford Model T (also known as "Tin Lizzie," or "the Flivver") put America on wheels. The Byers Brothers' Ford dealership, located on First Street, was selling a 1924 transitional-model four-door sedan for $685. The author is not sure whether the side accordion gate was used to secure groceries or loose items.

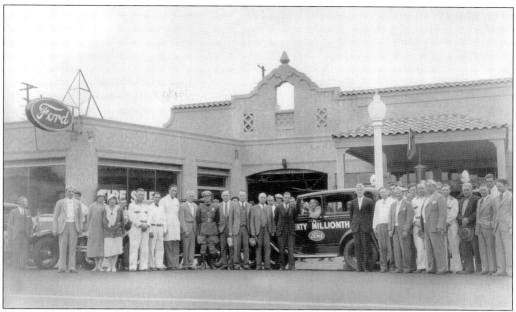

By 1931, more than 20 million Ford vehicles were roaming North America. This photograph shows a garage at 7747 Monterey Road in Gilroy. Gradually the wagons were phased out. The author's family had a 1934 Ford V-8 with a chromium-plated grill and swivel-type sun visors costing about $635. It had a hand-operated signal light, and when all else failed, the passengers had to hand crank or push start the engine.

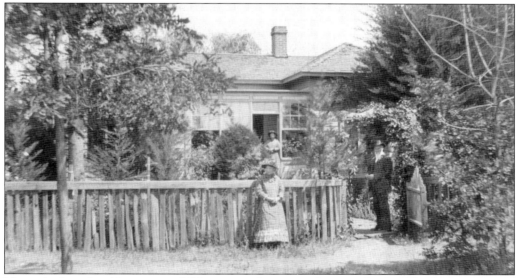

Homes built in the older section of Gilroy were of various architectural styles. This house, occupied by the Draden family in the late 1800s, was considered of modern design and had a windowed patio in front that let in plenty of sunshine. The plentiful redwoods of the area allowed the family to have a redwood picket fence. The home was located west of Ysidro at Chestnut and Sixth Streets.

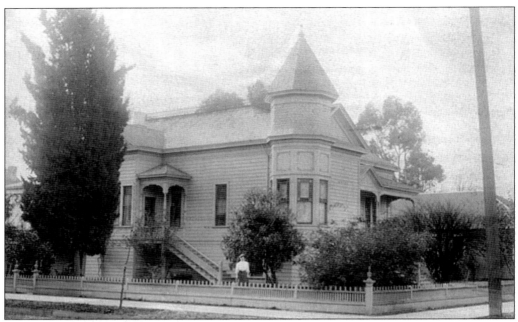

This 1903 photograph depicts the Annabelle Ellis residence, a Victorian-era mansion on Forrest Street. In 1907, the local telephone book listed Ellis's telephone number as suburban 541. (Courtesy of the Gilroy Museum.)

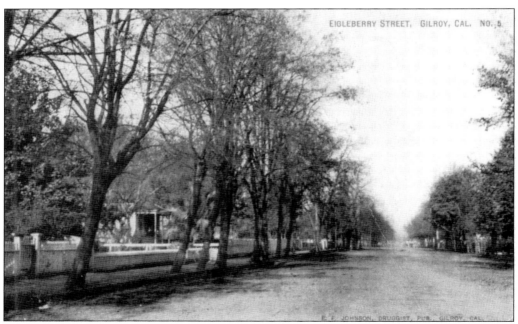

As stagecoach traffic increased, a downtown business district developed along Monterey Road. After 1850, many homes were built along Elgleberry, Church, Rosanna, and Hanna Streets. Gilroy was known for its wide roads planted with shade trees, as seen here. Many Victorian-era homes remain today.

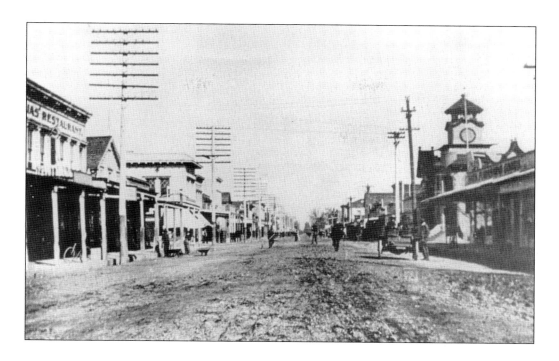

Because roads were not paved, rainy weather resulted in muddy paths and much inconvenience. The photograph above was taken in front of the old city hall in 1913. Beginning in the early 1920s, paved roads and modern automobiles made small towns like Gilroy enjoyable places to live and visit. To keep the major roads shady, Horace Greely Keesling launched a highway beautification project, and walnut trees were planted between San José and Gilroy to increase travelers' comfort and pleasure.

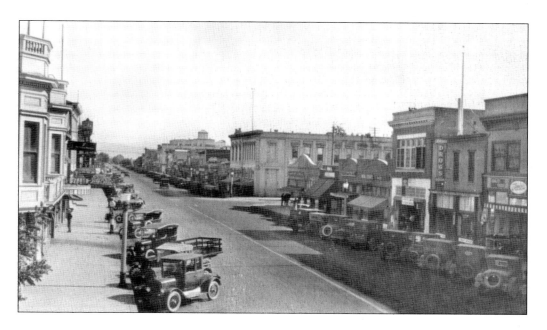

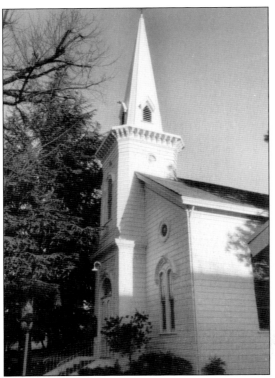

Situated at 160 Fifth Street in Gilroy, this Christian church is the oldest wood-frame church building in continuous use in Santa Clara County. Originally located at Third and Church, the structure was moved in one piece on buggies and hand jacks to its present location in 1886.

Architectural firm Wolfe and McKenzie designed the Gilroy City Hall in the Nordic-Mediterranean style. When completed in 1905, it was one of the most self-contained city halls in the area, as the courtroom, clerk's office, and fire department were all in the same building. It remained a government building until 1968 and later became a restaurant. This view reveals the restaurant from the railroad track on Sixth Street.

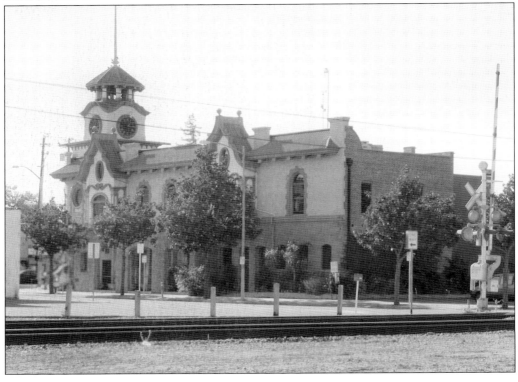

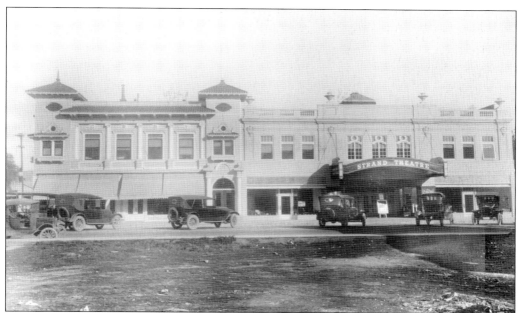

The Strand Theater was located at 7578–7590 Monterey Road. Designed by Reid Brothers and built by William Radke in 1921, it is a reinforced concrete theater with 900 seats. According to the *Gilroy Advocate*, the admission price was 10¢. Silent movies were shown, and the building was used for meetings as well. The theater closed in 1977 and subsequently became a Ford department store. Since the 1989 earthquake and the closure of the Ford chain, the building has stood empty.

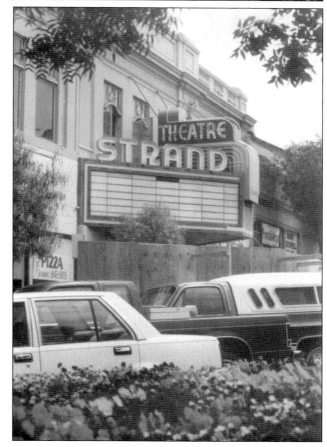

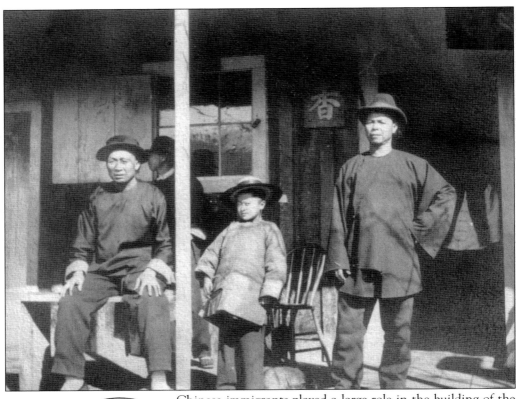

Chinese immigrants played a large role in the building of the railroad. In the mid-1800s, one-third of Gilroy's residents were Chinese, living on Monterey Road between Sixth and Ninth Streets. Many were employed in the tobacco industry; others became gardeners, cooks, washmen, and barbers. This photograph was taken in front of a Monterey Road store in the 1860s. (Courtesy of the Gilroy Museum.)

Because of prejudices of the time, the 1870 census listed most Chinese females as practicing the oldest profession. Only three out of 22 females were listed otherwise. Ah Lam was incorrectly labeled as a prostitute at the advanced age of 54. The lady in the beautiful embroidered dress, pictured in her 30s, was Ah Henry Ohn's first wife. She lived in Sargent, south of Gilroy. (Courtesy of the Gilroy Museum.)

Ah Henry settled in Gilroy after 1885 and passed away in 1925. He had four children: Lum, Louis (Bong), Esther (Chinese name unknown), and Nellie (Wong May Lau). Most second-generation Chinese Americans were—and are—better educated than any other ethnic group. Esther holds a nursing degree from the University of California at Berkeley. In these images, some are dressed in traditional Cantonese dress while others wear western clothes in 1908. Many men already had their queues cut off, indicating that they intended to stay in America. Some acquired telephone service as soon as it became available. (Courtesy of the Gilroy Museum.)

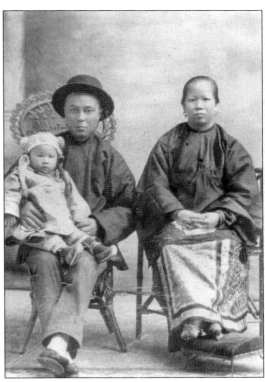

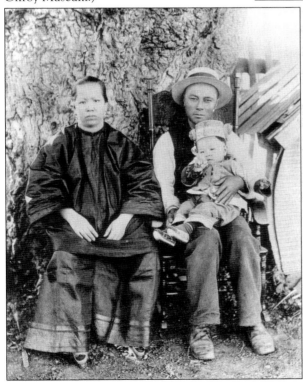

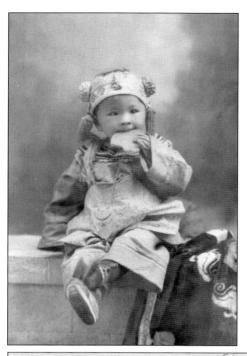

Baby Nellie Ohn wears a jade charm while eating bread in 1909. Nellie became a nurse, married a Stanford-trained physician, and took up residence in Palo Alto. A recession occurred during the late 1890s, and the subsequent relocation of the tobacco industry caused many Chinese to leave the area. (Courtesy of the Gilroy Museum.)

People with culinary skills were in demand. The lumber industry and private households always had room for Chinese cooks, and some were paid handsomely. This warrant from the Santa Clara County office shows that Ah Sam's pay for the month of December 1974 was $55. Flour cost 2¢ a pound, coffee 10¢ a pound, and meat 5¢. Ah Sam was well compensated for his work.

San Jose, Dec 31st 1874

SANTA CLARA COUNTY,

To Ah Sam Dr.

31 To Cooking &c for month Dec $55 00

Correct J.B. Church

State of California,
COUNTY OF SANTA CLARA

J.B. Church being duly sworn, deposes and says the above bill is correct, and no part thereof has been allowed or paid, and that the same has not been heretofore presented to or rejected by the Board of Supervisors.

Subscribed and sworn to before me, this 2 day of Jany 187 5

J.B. Church

C. Finley Clerk

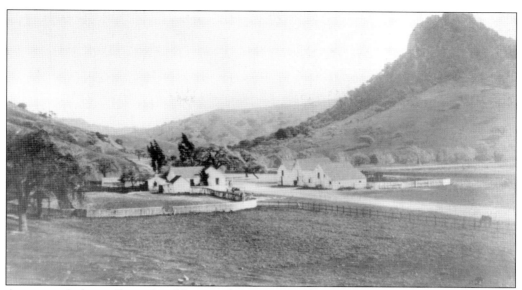

Ausaymus Indians, Spanish soldiers, and Argonauts all used a mountain pass in the Diablo Range that connected Los Baños in the Central Valley to the Valley of the Heart's Delight in Santa Clara County. Butterfield Stage began coach service in 1859, connecting St. Louis to San Francisco. The pass was a private toll road when these photographs were taken. Toll fees then were $1 for a wagon and 25¢ for a horse and rider; pack animals were 10¢, and cows just 2¢ each. A tavern stood across from a 2,845-foot-high rocky peak. In 1863, the tavern was sold to Lafayette Bell and became known as Bell Station. The place, as pictured below, provided lodging for weary travelers and corrals for animals.

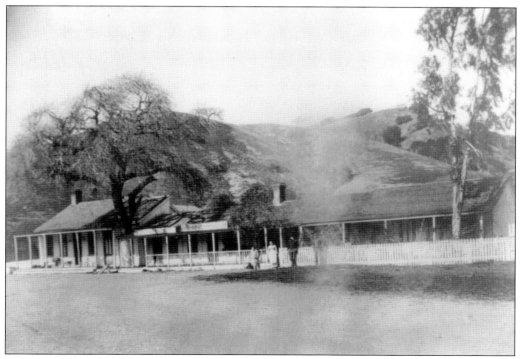

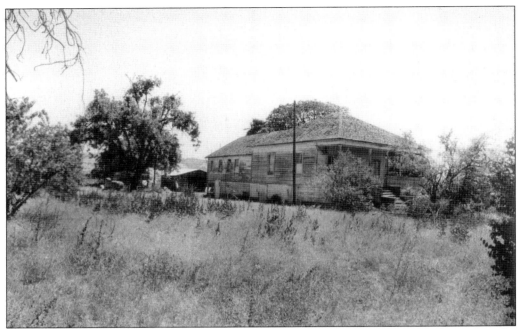

The west side of present-day Gilroy, known as San Ysidro, is one of the oldest districts in the county. San Ysidro Village grew out of the original Spanish settlements and was named after the Ortega family's land grant. Some of the Anglo settlers who took up residence were Claudio Dudit, Barbechon, Harrison and Bruen, Allen and Smith, and Barnes and Newcomb. Isaac Hale owned a hotel in San Ysidro in 1888. Today a number of crumbling buildings line both sides of Route 152, including the one above at 1855 Pacheco Highway near Holsclaw. Both photographs were taken in the 1960s. (Courtesy of the Santa Clara County Archives.)

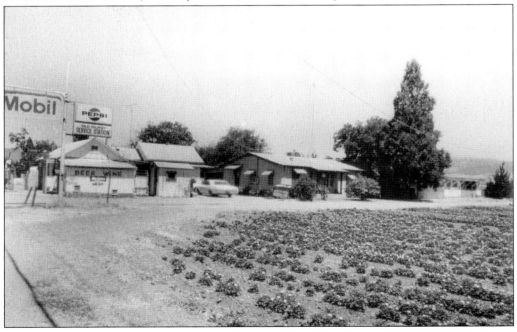

In 1920, a paved road was built and named Pacheco Pass or Highway 152 East, heading to the San Joaquin Valley. From Bell Station eastward there are several sharp turns on the two-lane highway. Because many accidents occur, officials have proposed to reroute the road. The view below of Hecker Pass Road is dated 1941. Hecker Pass Road, also known as Highway 152 West, leads to Watsonville. The dedication of the pass took place on May 27, 1928. Previously, one had to travel to Mount Madonna Peak through the old Watsonville Road. That defunct road is still passable. The newer 152 West includes windy turns (pictured below), and visibility can be just a few feet due to fog both in the summer and winter.

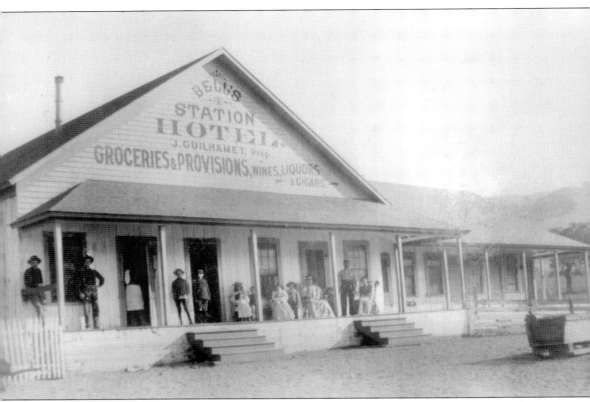

In addition to being a hotel, Bell Station sold provisions, groceries, liquor, and cigars. People were in a hurry to come and go in their automobiles, eventually contributing to the decline of the stop. Other than a forest fire station nearby, little is left. Remnants of the 1852 wagon road and tollhouse can be seen on the hill from Route 152 East as reminders of a bygone era.

Five

SAN MARTIN AND THE EAST

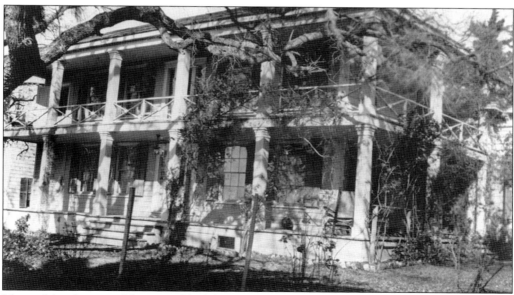

Martin Murphy moved from an old adobe near Madrone to San Martin to expand his business. Through marriage with the Fishers and success in the cattle business, he owned more than 75,000 acres of land—virtually all of South Santa Clara County. He built a huge two-story house at what is now the corner of San Martin and New Avenues. His estate was a self-contained village; lately there has been a proposal to incorporate San Martin.

This Presbyterian church, which Murphy named San Martin in honor of his patron saint, serves as the local landmark. Built under a 300-year-old live oak tree, it has been open to the public since 1898. The first minister was rancher William Hersman. Below, the back window of the sanctuary looks out onto the trees of downtown San Martin. The same trees can be seen on page 122 of the 1895 book *Sunshine Fruit Flowers of Santa Clara County.*

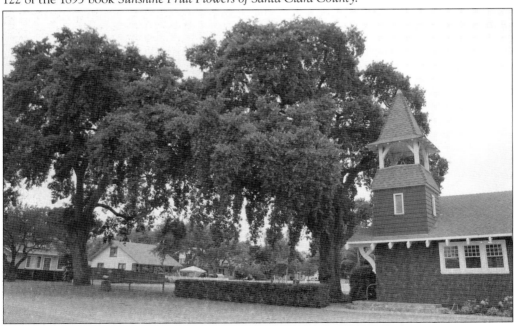

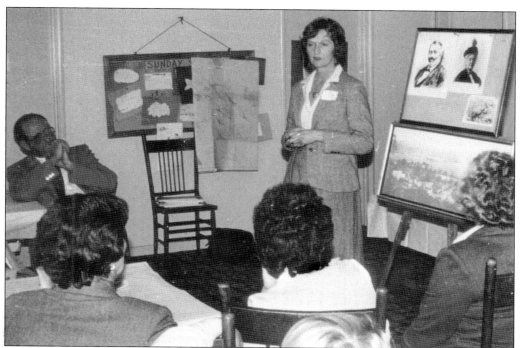

Beth Wyman, former Morgan Hill mayor and historical heritage commissioner for the county, visited the Sunday school at San Martin Presbyterian Church to give a talk about local history. At right, the church celebrated a renovation project and released balloons at its reopening. (Courtesy of D. Pierce.)

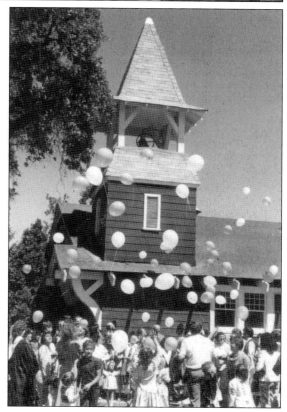

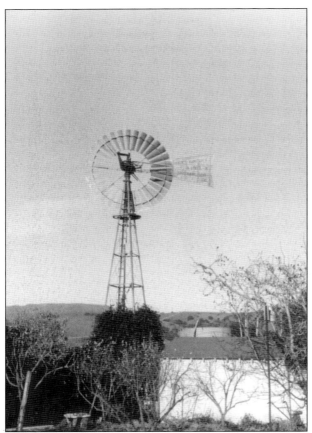

San Martin is dotted with wind-powered pumps. Windmill-propelled engines come with multiple metal blades so they can turn slowly with considerable torque in a low breeze and also self-regulate in high winds. A tower-top gearbox and crankshaft convert the rotary motion into reciprocating strokes to pump water from wells. Near each wind pump is a tank that stores water for agricultural use and human consumption.

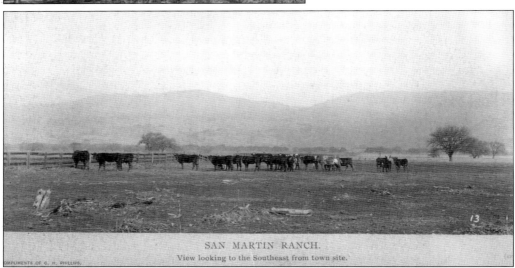

SAN MARTIN RANCH.
View looking to the Southeast from town site.

In 1894, Catherine Dunne's vast landholdings were split into 5-, 10-, and 20-acre parcels of flat land, as well as larger hillside parcels. The news made headlines in the *Morgan Hill Times*. Using satellite technology, three-dimensional maps, and a GPS, the author determined that the area shown on this 1892 flyer was on current-day Hill Road, south of San Martin Avenue.

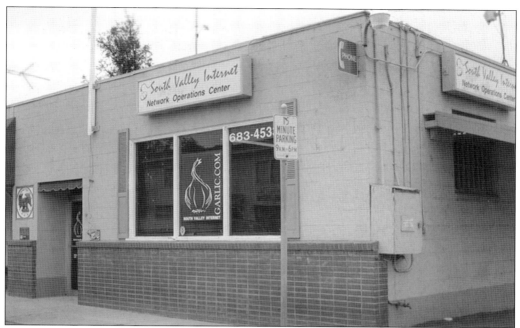

The San Martin Post Office was originally established in 1894 and reopened in 1902 near 95 East San Martin Avenue. The first postmaster was Christopher Mangels. Many recalled that the place had an antique bar window at the counter; only a U.S. Postal Service logo on the front of the building indicated that it was a post office. When services were expanded, the facility moved across San Martin Avenue to the new building shown below. The old site is now the home of Garlic.com, a local Internet service provider.

Irv Perch, founder of the Jetstream travel trailer business, owned many airplanes. In 1977, Irv and his wife, Jan, opened a museum displaying up to 104 planes. Many visitors enjoyed the collection, which included a Mustang P51 fighter, a Messerschmitt 262 jet, and a B-17 bomber. Inside the museum restaurant, the *Flying Lady*, a full-scale airplane hung in the dining room. In addition, model planes moved around overhead, suspended from a converted dry cleaner conveyer. Eclectic wooden statues stood near the restaurant walkway; in 1989, a section of the walkway collapsed, as pictured below. The new owner is John Fry, chief executive officer of Fry Electronics. The 18-hole golf course will stay, but the old restaurant will soon be replaced by a 167,000-square-foot building housing the American Institute of Mathematics, founded by Fry.

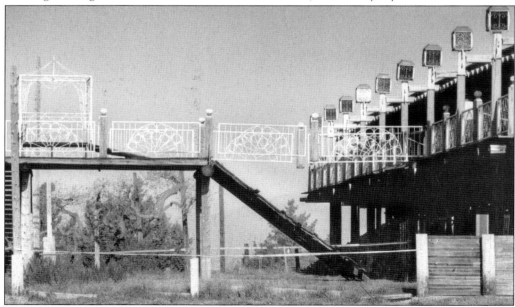

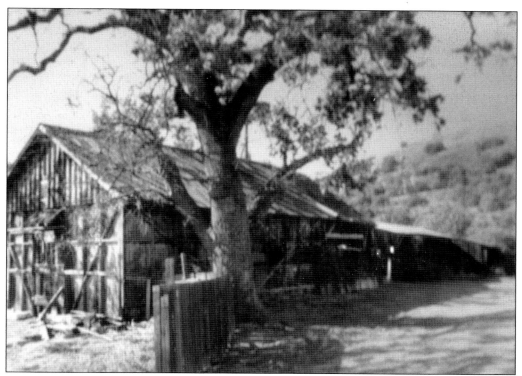

Henry W. Coe State Park is named after the family who lived there from 1905 until 1948. Over the years, additional ranches were purchased, bringing the size of the property to 86,000 acres. Buildings from the 1870s are still standing in the park. The terrain is rugged, varied, and beautiful, with lofty ridges and steep canyons. Some residents had to do without telephone service until the arrival of cellular phones. In spite of the modern road network, fire trucks can barely reach the area. A massive eight-day fire burned 47,760 acres on the east side of the park in September 2007. The smoke was seen for miles. The photograph below was taken from across the valley in Morgan Hill, near the 21 Mile House.

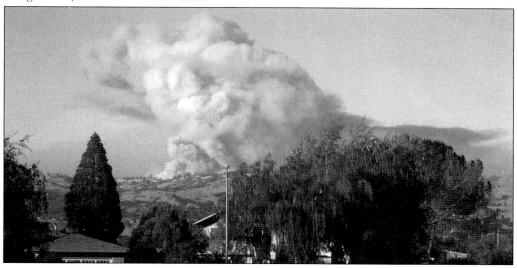

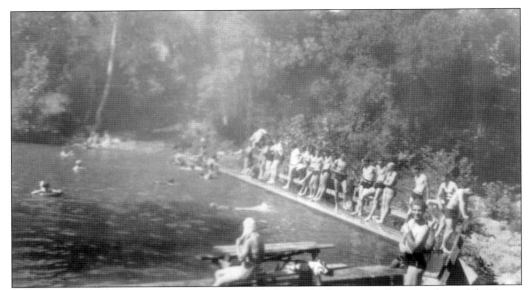

The Anderson Dam and Reservoir were named for Leroy Anderson, the first president of the Santa Clara Valley Water Conservation District. In 1950, the dam and reservoir were constructed on Coyote Creek on a 500-acre dairy and cattle ranch purchased from John and Aphelia Cochran. Island Dell, depicted in 1949, is now underwater. (Courtesy of M. Gunter.)

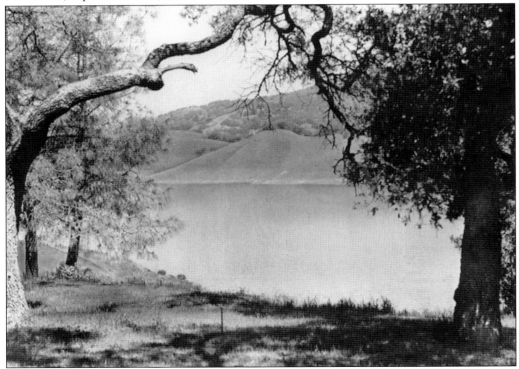

Anderson became the largest man-made reservoir in the county, covering 1,271 acres with a capacity of 90,373 acre-feet of water. It receives water from the Coyote Reservoir effluent. As a recreational area, Anderson Reservoir provides residents with boating, fishing, and hiking opportunities.

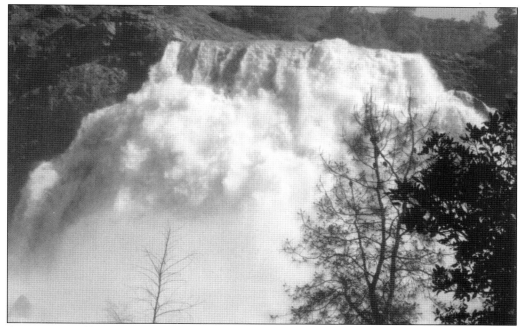

Average rainfall in Santa Clara County is about 12.8 inches. In a drought season, old tree trunks and submerged bridges on the lake bottom are partially visible. During wet years, which occur every decade or so, the reservoirs in the area become full. Visitors observe water cascading over the spillway.

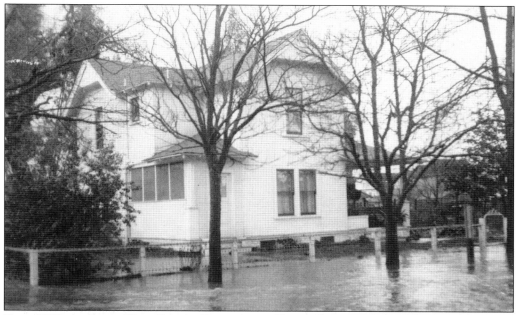

Since 1929, the Santa Clara County Conservation District has provided sandbags and guidance after each flood. In the old days, people helped one another cope with problems caused by flooding. Shown here are the effects of a 1931 storm near Morgan Hill. The water district also advocates conservation and educates people on pollution issues.

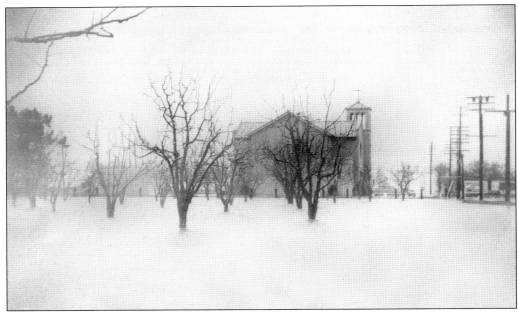

In the past, flooding halted transportation and inundated hundreds of acres of orchard and pastureland. These photographs were taken downtown in 1931 (above) and at Monterey and Leavesley Roads in 1955 (below). The South Santa Clara Valley Water Conservation District was later formed to build more reservoirs and percolation facilities in order to better manage creeks and groundwater in the area. (Courtesy of the Gilroy Museum.)

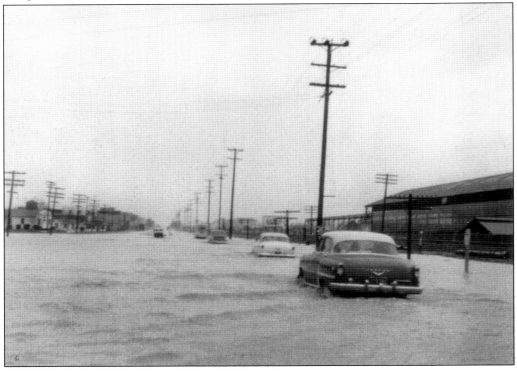

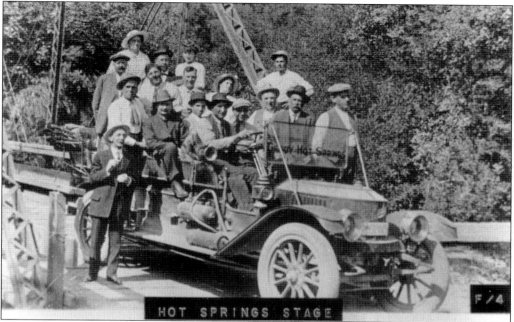

Gilroy Hot Springs is situated eight miles east of Morgan Hill, off Cañada Road. Development of the resort started in 1866, and cabins, a bathhouse, a pool, a clubhouse, and a three-story hotel were gradually added. In 1938, a Japanese businessman built several Japanese-style cabins tailored to foreign tourists, using materials from the World's Fair Japanese Pavilion. To enter the resort, one needed to drive or ride across a bridge over Coyote Creek. The above photograph, taken near the entrance bridge over Coyote Creek in 1920, shows happy visitors on a shuttle that picked them up at the Gilroy train station. (Courtesy of the Gilroy Museum.)

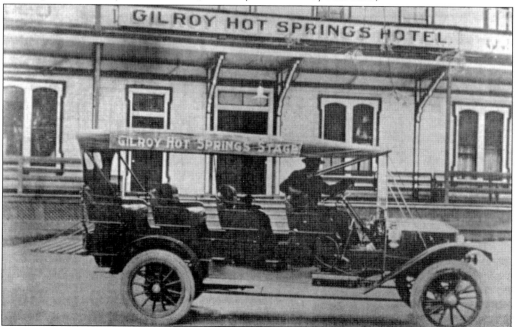

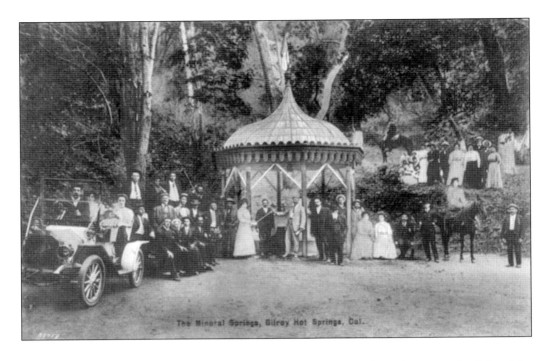

The above photograph, taken in the early 20th century, shows folks gathering at the Gilroy Hot Springs gazebo. Below, tourists enjoy a game of croquet in the late 19th century. (Below, courtesy of the Gilroy Museum.)

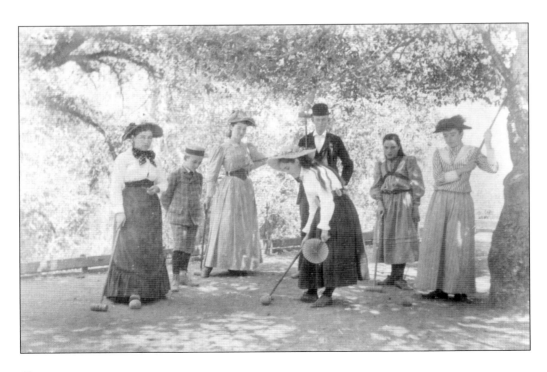

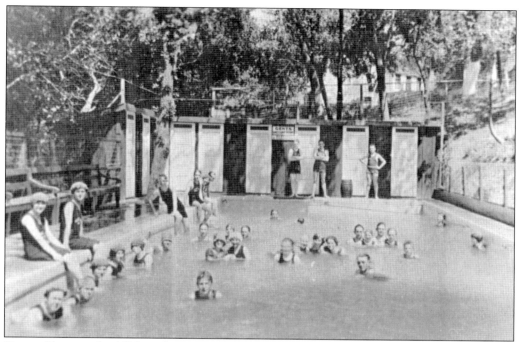

Pictured here in the 1920s is the coed pool, one of two pools at Gilroy Hot Springs.

HOTEL REGISTER

Money, Jewelry and other Valuables must be placed in the Safe in the Office otherwise the Hotel will not be responsible for any loss.

As Gilroy Hot Springs was under Japanese American management, there were many attempts to bring tourists from Japan to the resort. Here is a sample hotel register of visitors in late 1950.

Coast live oaks (*quercus agrifolia*) are an evergreen oak native to California and found along the coast from Mendocino County to Baja, California. They can reach up to 100 feet tall and 15 feet in diameter. Many live to be 250 years or more. The Costanoan Indians used the acorns as a dietary staple.

Six

AGRICULTURE

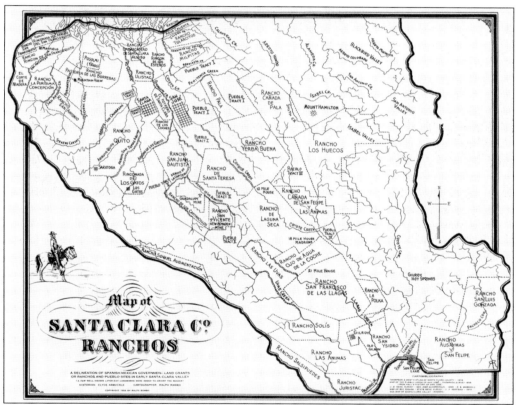

Map of SANTA CLARA C?. RANCHOS

A DELINEATION OF SPANISH-MEXICAN GOVERNMENT LAND GRANTS OR RANCHOS AND PUEBLO SITES IN EARLY SANTA CLARA VALLEY

HISTORIAN: CLYDE ARBUCKLE CARTOGRAPHER: RALPH RAMBO

Any person living in Alta California who was a Mexican citizen and a Catholic could apply for a land patent and receive up to 48,712 acres for free. Between 1859 and 1881, twenty-five land patents totaling 317,244 acres were issued in South Santa Clara County. Through marriage and cattle trading, the Martin Murphy family became the largest landowner in Santa Clara County. The Murphys first paid $1,500 to buy 8,927 acres from Juan Hernandez, an earlier settler who owned the Pigs Eye Ranch. By 1865, they owned 51,351 acres—four percent more than the maximum allowed by law. All the ranchos in the area are shown on this map by Rambo.

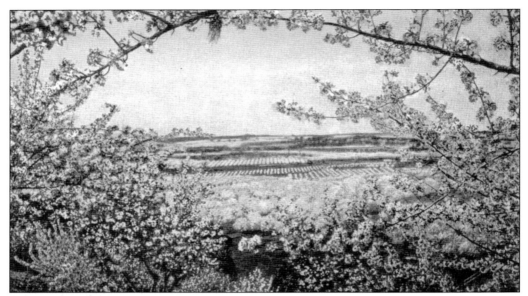

According to the narration of the 1922 film *Valley of Heart's Delight*, "The Valley of the Heart's Delight is a place where life is favorable, toil is honorable, and recreation is plentiful." In the springtime, fruit blossoms bloomed profusely from one side of the valley to the other. Blossom Hill Road and Highway 85 are both situated on former orchard land.

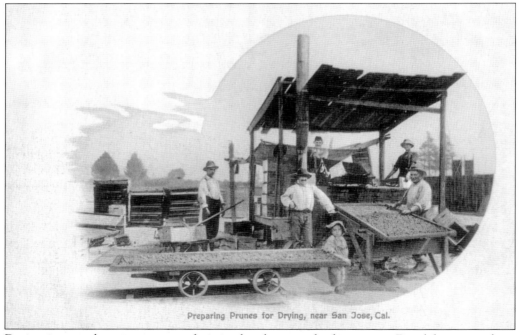

Preparing Prunes for Drying, near San Jose, Cal.

Drying is a good way to preserve fruit in the absence of refrigeration. Dried fruit provides a favorable alternative to fresh fruit, as it has a longer shelf life and makes out-of-season items available year round. Dehydrators using natural gas reduced drying time from days to hours. As a result of the drying process, the fruit loses Vitamin C and seven-eighths of its original weight; it also has a richer smell.

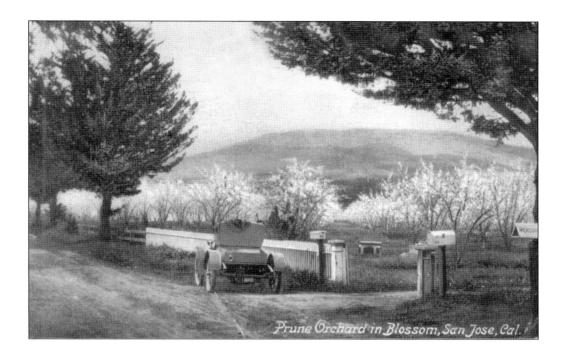

Prune Orchard in Blossom, San Jose, Cal.

In 1919, some 98,152 acres were planted with fruit trees, including 7.652 million prune trees. The area produced one-third of the prunes consumed globally, and more prunes were grown here than in the rest of the country. Shown above are prune and other fruit blossoms near Los Gatos in the 1920s. During World War I, sun-dried fruits were sent overseas as dietary supplements for soldiers fighting in Europe. Below, workers near Morgan Hill sort prunes in preparation for packing and shipping.

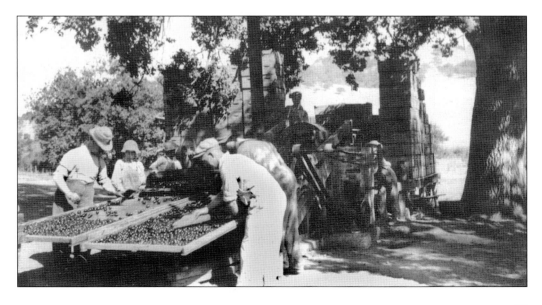

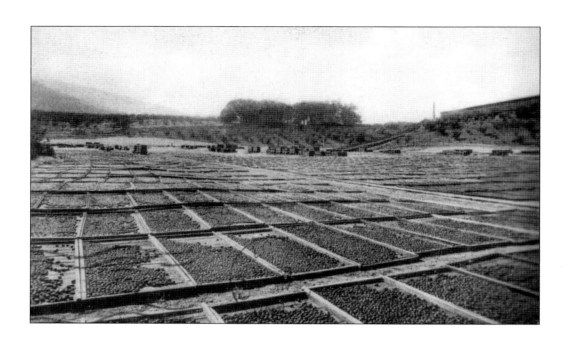

With 482,000 trees planted, peaches were the third largest fruit crop in the county. Here peaches are being dried in the sun. The process of adding sulfur powder to prevent discoloration was invented locally. The photograph above was taken near East Hills.

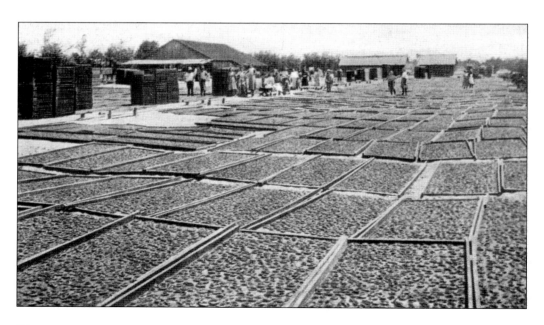

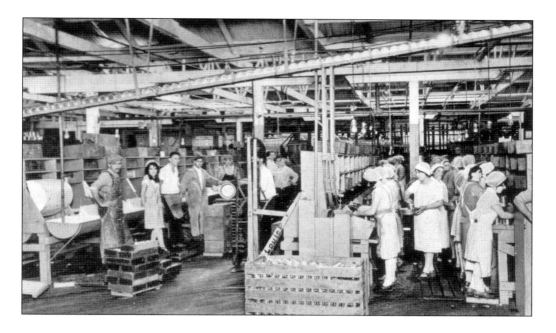

As Santa Clara County is the largest fruit-growing district in the state, it is naturally also the largest canning and packing district. In 1922, California Prune and Apricot Growers owned and operated 30 packinghouses. Most of the packing operations were located in downtown San José, with FMC (Food Machinery Corporation) providing much of the equipment. The industry packed 30,000 tons of fruit and employed 1,000 people. The photograph below of the Morgan Hill Farmers' Union was taken around 1915.

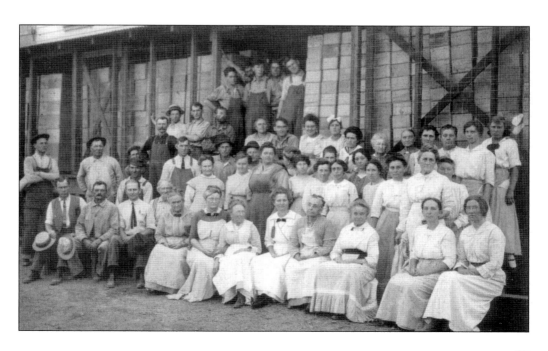

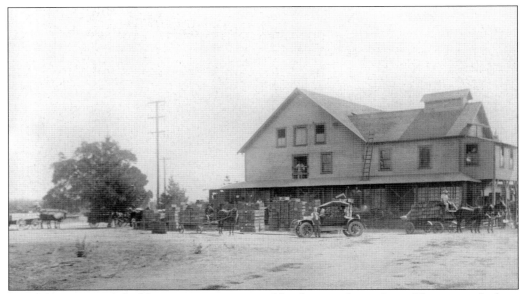

Dried fruits were packed by cooperative unions like the one shown here. The union dealt in volume and could ship by rail at a maximum discount. It also allowed farmers to concentrate on tending their orchards. Here is a bird's-eye view of a packinghouse and a group portrait taken in Morgan Hill around 1915. Note that both a Ford truck and wagons were used to deliver produce to the farmer's union. Today the tree on the left and the empty lower floor are all that remain of the Fourth Street operation.

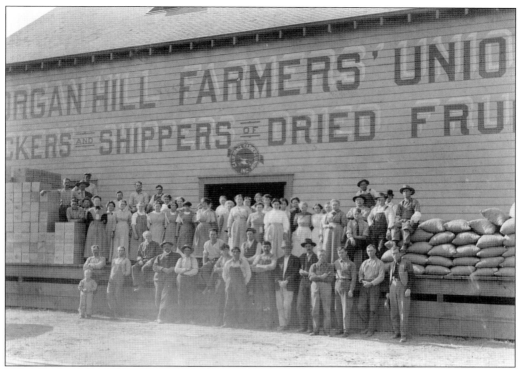

The Morgan Hill Farmer's Union is pictured in 1918, five years after the building was constructed. This union was one of the largest packers in the South County at the time. By 1939, with 18 canneries and 13 dried-fruit packinghouses, the county had become the largest canning and dried-fruit packing center in the world. It also had the most advanced food machinery.

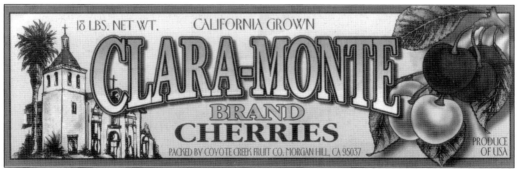

Virtually hundreds of attractive designs were used by packers to market their products. This label is from an 18-pound Coyote Creek Fruit Company can that was sent from Morgan Hill to purchasers all over the world. Collecting the can labels can be fascinating, as there are so many different designs, some featuring bilingual advertisements for overseas destinations.

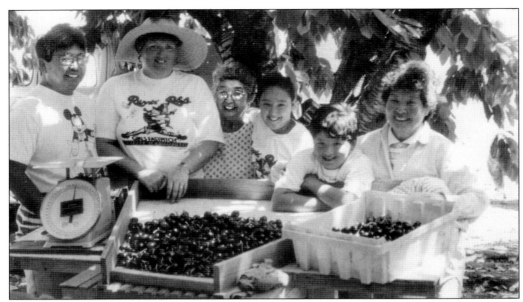

Santa Clara County was for many years the fruit capital of the world. As Silicon Valley attracts more and more high-tech workers, the agricultural land gives away to housing. When landowners sold their property to developers, sharecropper Toshiko Masuoka and her family left Cupertino for Willow Glen and finally moved to Morgan Hill in 1957 to grow strawberries, Bing cherries (named after horticulturalist Ah Bing), and persimmons. Here the Masuokas prepare to take their produce to Nob Hill. They, like others, wonder how long it will be before their present farm is converted into housing developments. At another ranch below, neglected machinery serves only as a reminder of the past.

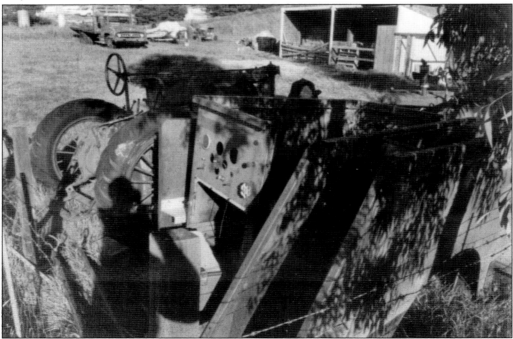

Zard Emeline Bagwill sent this postcard from Morgan Hill to the Golden Gate Packer Company in San José to describe the quantities of cherries (1,515 boxes) shipped. Earlier growers needed to have several professions to make ends meet; the phone directory listed Bagwill's profession as butcher and rancher. He owned two parcels in Morgan Hill, and his charming 1930 house still stands at 75 West Third Street.

Morgan Hill
FARMERS' MARKET

Fresh from the Farm!

Holiday Harvest
Farm-Fresh Gifts!
Saturdays, 9am-1pm, through Dec 22nd

By 1984, not enough orchards were in existence to keep the Sunsweet drying plant in business, and so it closed for good. The drier and farmer's union were located adjacent to each other. There are plans to add a new retail space for recreational activities and an additional 57 units of mixed-use development between Third and Fourth Streets on Depot Street in Morgan Hill.

Morgan Hill is still active in farming produce. Its farmers' market draws people from all over.

Of the 13 wineries in Santa Clara County, 11 are located in the southern section. Emilio Guglielmo, pictured here at his 1910 wedding, came to Morgan Hill from Italy and started a winery business in 1925. For three generations, the family has been making fine wine and has won many awards. Visitors to the winery are greeted by a cobblestone piazza reminiscent of the Italian Piedmont. The Guglielmos have made fine local wines like the Mount Madonna Sauterne from 1950. Collecting labels can be fun.

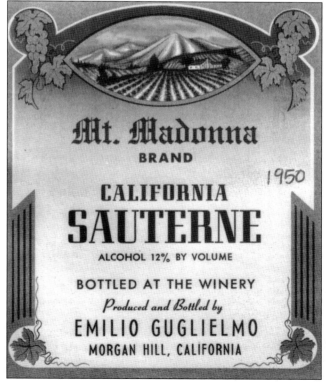

Some customers prefer to bottle their own wine and apply their own labels. Wineries make and sell many types of wine. Winemakers, or vintners, are in demand in California. The Guglielmo winery produces about 40,000 cases annually under several names: Guglielmo Private Reserve, Villa Emile Varietal Wines, and the oldest label, Emile's.

Grapes are crushed, put through the first fermentation, and then stored in wooden barrels for several months for secondary fermentation and the bulk aging process. The sugars are slowly converted into alcohol, and the wine becomes clear. The time from harvest to drinking can vary from a few months to more than 20 years for top wines. However, only about 10 percent of all red wines and five percent of white wines will taste better after five years.

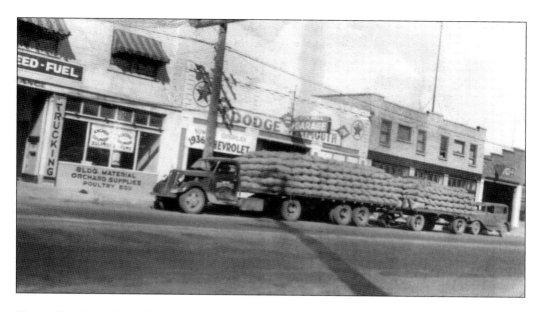

Gunter Brothers, located at 17590 Monterey Road (today's Wells Fargo Bank) in Morgan Hill, had to engage in several businesses to survive. In addition to hay, grain, feed, fuel, and trucking, the firm dealt in building materials, orchard supplies, poultry, and eggs. The company's 1937 Ford truck hauled heavy loads with just an 85-horsepower gasoline engine. A broomstick was used to jam the accelerator to get over Pacheco Pass. Water from a 20-gallon tank sprayed onto the radiator and engine to keep them from overheating. The signal signs were manually operated using a hand crank; arrow down meant the truck was going forward, as seen below.

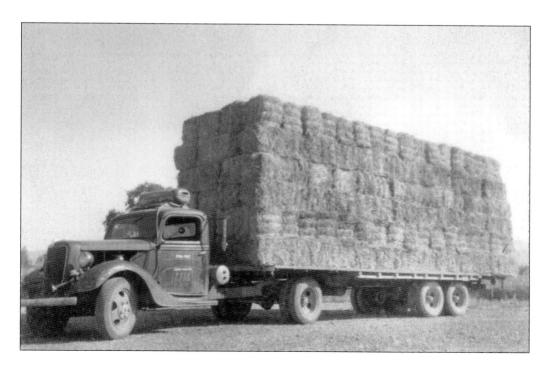

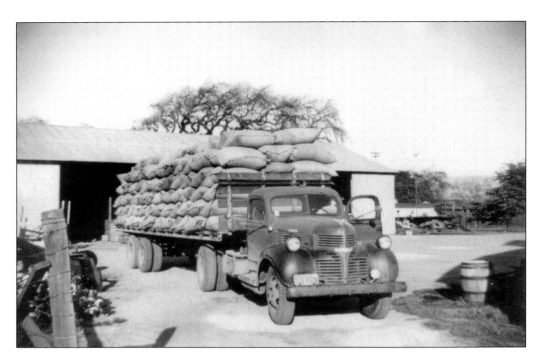

Better and more comfortable trucks came along later. In 1941, the Gunter Brothers store started using a Dodge two-ton truck with a powerful diesel engine, five-speed automatic transmission, and air-conditioning. Such trucks were a familiar sight along American highways. The good life did not last long; in 1961, a fire scorched part of the Gunter operation (as illustrated below).

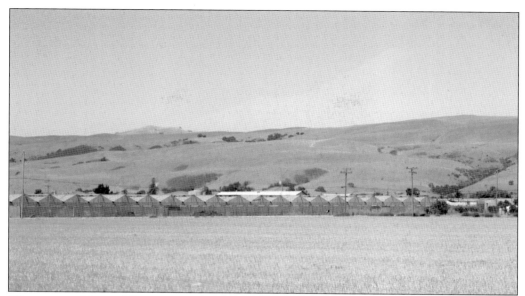

Winter vegetables and flowers were planted inside a greenhouse, where humidity and temperature could be controlled. The high cost of the natural gas used to warm plants at night soon became prohibitive for most nursery crops in Santa Clara County. Chrysanthemums, for example, cannot be profitably grown and are now flown in from Central America. Nursery crops have decreased since 2000 but still carried a retail value of $113,641,500 in 2002; specialty crops such as herbs and bok choy continue to earn top dollar.

When Highway 101 was opened parallel to the Monterey Highway, many fruit stands moved to Cochran Road to pick up business from 101 exit traffic. Sullivan's Last Stand was a familiar place to shop until more last fruit stands cropped up along newly completed sections of 101. Sullivan's finally closed its doors in 1985, when Highway 101 construction was completed. The closing of these stands signified the demise of the agriculture industry in general. This area is now a strip mall.

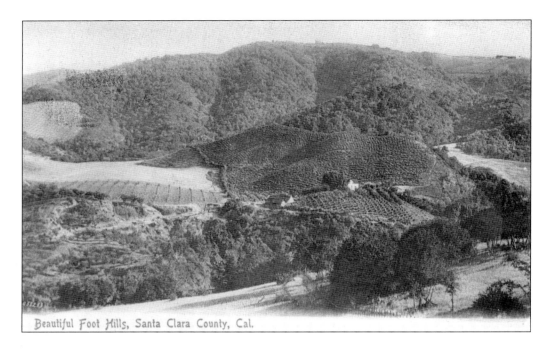

Beautiful Foot Hills, Santa Clara County, Cal.

This postcard view of the west and south areas of the Valley of the Heart's Delight shows a rural setting and quiescent life that have disappeared forever. Development and encroachment from nearby cities have all but destroyed the agricultural base. Below, the postcard shows Blossom Valley with Mount Umunhum.

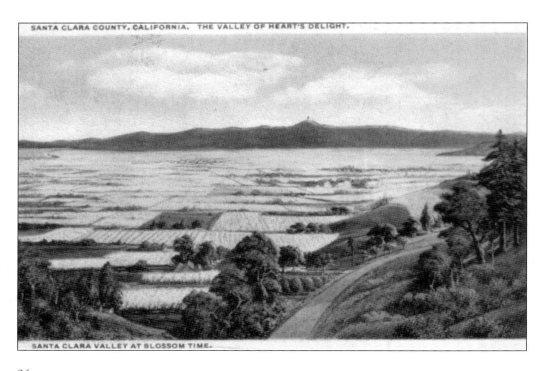

SANTA CLARA COUNTY, CALIFORNIA. THE VALLEY OF HEART'S DELIGHT.

SANTA CLARA VALLEY AT BLOSSOM TIME.

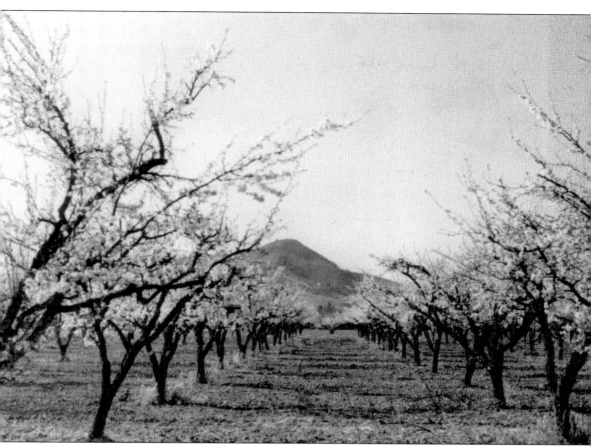

El Toro is seen in this photograph taken 50 years ago. San Martin is now dotted with developments.

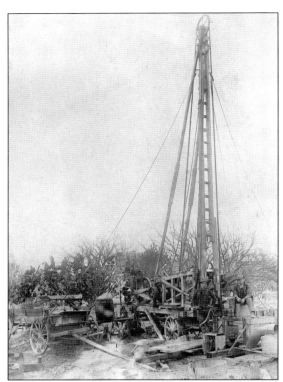

The valley only receives an average rainfall of 12 inches per year. To obtain water for irrigation, many water wells were drilled, as shown here in 1920.

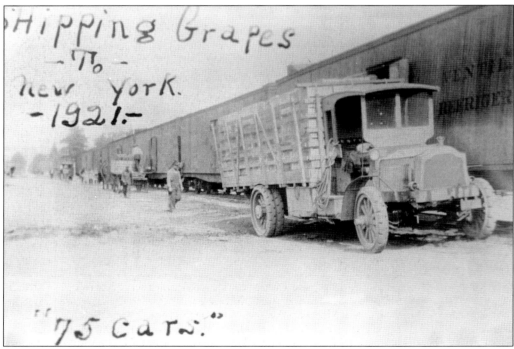

Hipping Grapes
- To -
new York.
- 1921 .-

"75 cars."

Grapes were a major export from the valley. In 1921, the amount of grapes being shipped to New York required 75 train cars.

Seven

TRAINS AND DEPOTS

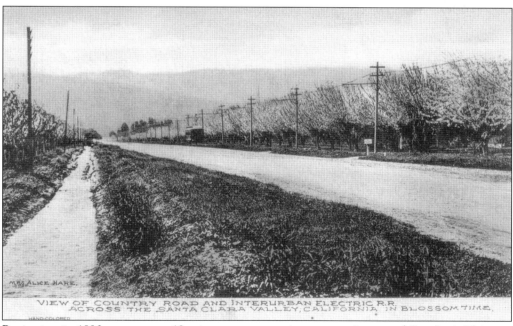

Beginning in 1890, as many as 18 private transportation companies served San José. Thirteen Interurban connected San José to suburban areas. In this postcard view, the San José–Saratoga train runs down the right side of Meridian Avenue in the springtime. The SJ-Saratoga operated from 1904 to 1933. Most of the private streetcars were taken over by Peninsula Transit, San José City Lines, or Peerless Stages. In 1974, the Valley Trasient Authority (VTA) consolidated these financially troubled firms. The railroads went through a number of similar reorganizations to become Caltrans.

Under contract with Amtrak, Caltrans started providing faster service between San Francisco and Gilroy. This photograph depicts the opening celebration held at Morgan Hill's new train station in 1992. Cowboys and police waited for the first train and staged a mock robbery on Congressman Mike Honda's entourage.

To commemorate the reactivation of the station, which had been closed since the 1920s, flappers entertained visitors by dancing the Charleston. The new train station, located one block away from the abandoned stop, boasts a Starbucks coffee shop, a large parking lot, and handicapped access.

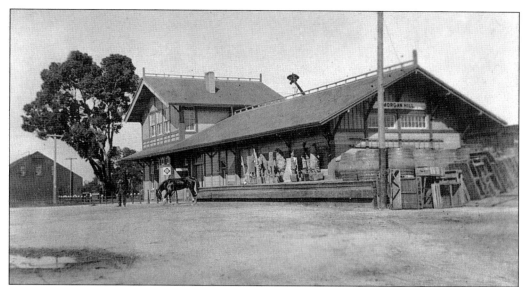

In the 19th century, the Southern Pacific train stopped at the 15 Mile House in Coyote; it also stopped on demand behind Villa Mira Monte for H. Morgan and Diana Murphy Hill. In the 1920s, a train station was constructed on Depot and Second Streets. However, local train service could not compete with car and truck transportation, and the depot was demolished in 1956.

A new commuter train station with ample parking was built at Third and Depot in 1992. The commute from Gilroy to San Francisco takes 57 minutes. Some of the new Baby Bullet trains even provide electric outlets for laptops. Parking lots are provided at each stop (called "mile houses" just 100 years ago).

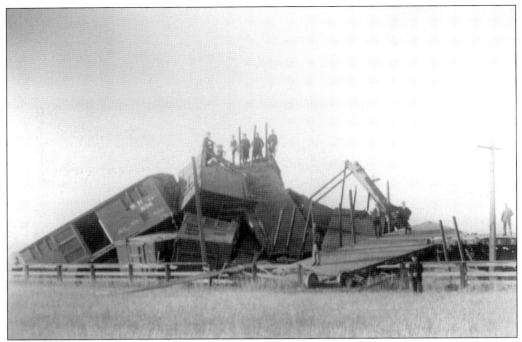

Construction of the train tracks followed an exacting schedule. Track, switching, and communication problems interfered with the smooth and safe operation of the trains. Frequent accidents, such as this 1895 wreck near Sargent Station, were common. The 1920 photograph below shows a boxcar with a broken wheel. As recently as the late 1990s, passengers were showered with Pepsi when a Caltrans commuter train collided with a Pepsi truck near Madrone.

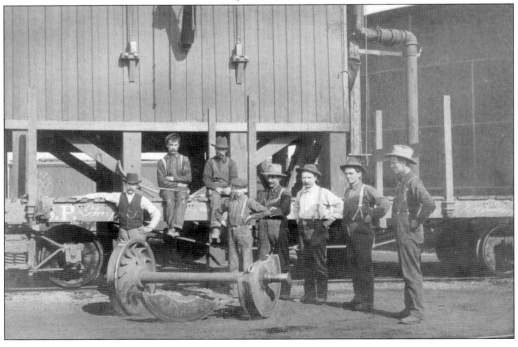

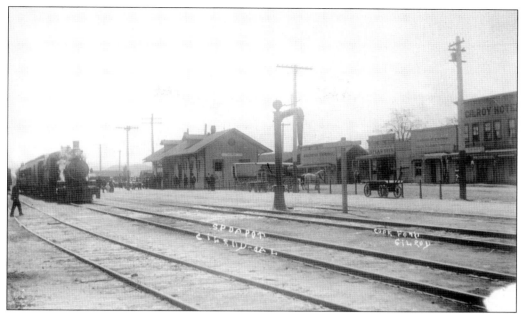

Before the invention of automobiles and paved roads, the train was the most efficient way to travel. The Gilroy depot was constructed as early as 1870, the same year as the city's incorporation. Water towers behind the station replenished the water used by the steam engine boiler. Note the hotel and bars conveniently located adjacent to the original depot.

With the advent of the Model T Ford, taxis and privately owned vehicles shuttled people to the Gilroy depot. In the late 1910s, before a highway infrastructure was established, it was very fashionable to take long-distance trips by train. The car in the rear, with the designation of Gilroy, appears to be a taxi.

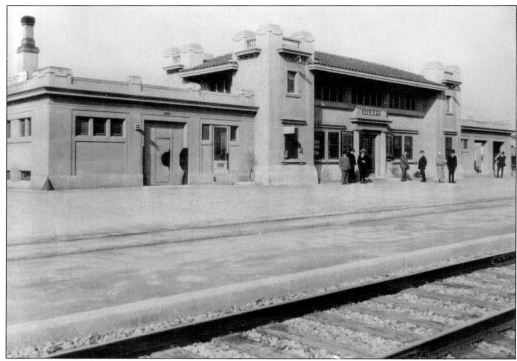

A bigger depot was eventually needed, and in 1918, a beautiful Italian Renaissance–style structure with two side balconies was built of reinforced concrete at a cost of $13,000. An article in the *Gilroy Advocate* mentioned that it even had a pay phone. It was the most up-to-date depot between San Francisco and Santa Barbara at the time. The image below provides a view of the waiting room in 1940. The station is still in use; in 1998, it was restored after having been closed for 20 years.

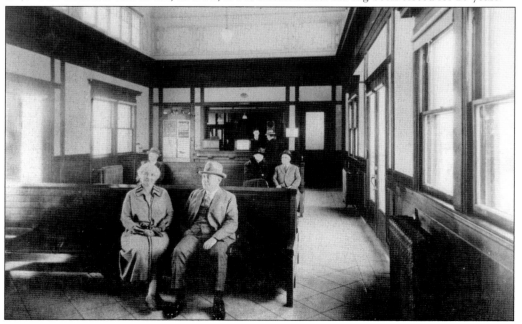

Eight

PUBLIC SERVICE

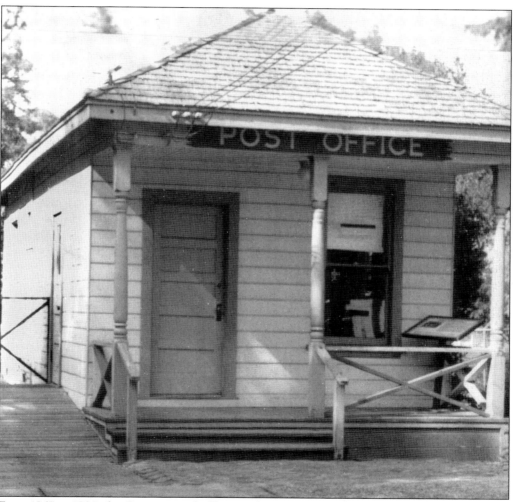

From 1862 to 1884, the Coyote postal office was located within the 12 Mile House. The original building is now part of San José Historic Park. Over the years, a one-person post office has served Coyote on and off, depending on the budget. The current office is located just south of the original, near the Fisher House at Monterey and Coyote Ranch Roads.

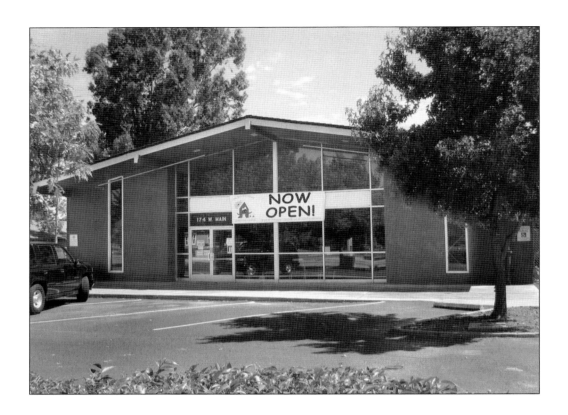

The post office stood at 174 West Main Street from 1961 to 1989. At one point, a post office plaque in front of the leased building was removed, and postmaster Joseph Morabito received it as a retirement memento. Today the facility is used as a private learning center. Increased demand for postal services in the area resulted in the opening of a modern building at 16600 South Monterey Road. Below is a 1989 first day cancel cover.

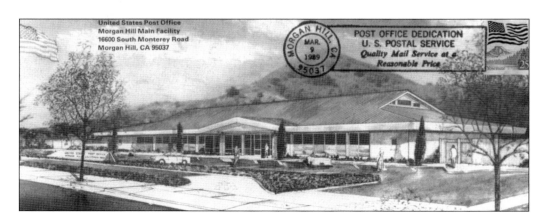

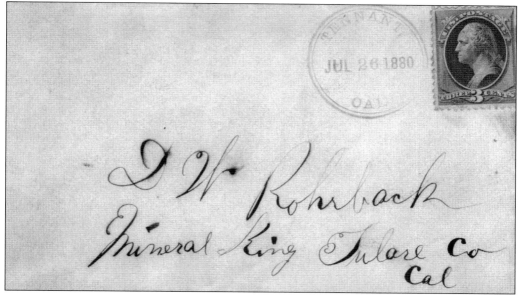

The Morgan Hill Post Office was established in 1893. According to Joseph Morabito, it was initially on Monterey Road near Second Street and was later moved to Third Street. Several mile houses also served as postal stops. This rare 1880 cover is addressed to "Mineral King, Tulare County [east of Sequoia National Park]" and was canceled at the 21 Mile House when John Tennant was postmaster. (Courtesy of John Drew.)

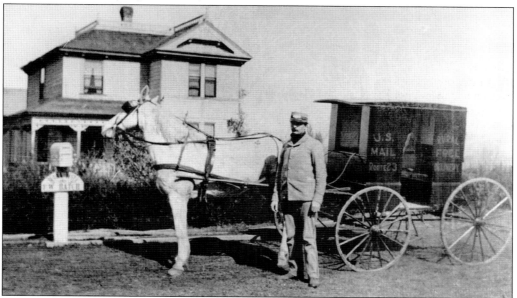

Buggies were used for rural free delivery. Beginning in 1902, all mail was delivered to the recipient's residence. The exception was the Uvas Valley, whose residents still had to pick up their mail at the Morgan Hill Post Office. Here the mailman from Route 23 delivers to F. W. Hatch's house; the address would be RR23 Box No. XX, Morgan Hill, California. However, with the introduction of emergency 911 services in 1968, every household had to have a street address. Route 6 was Coyote, as indicated by some older mailboxes in the area.

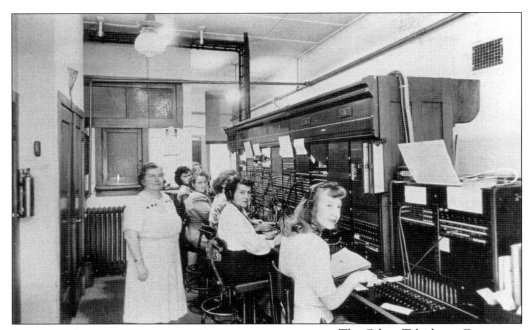

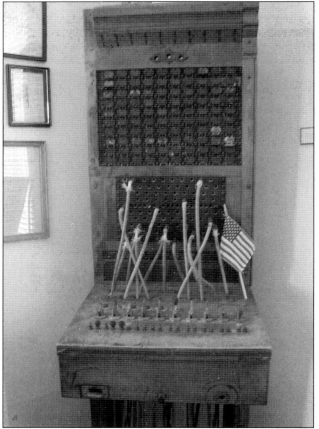

The Gilroy Telephone Company was located in a two-story building at 7525 Monterey Street starting in 1911. In the photograph above, Fanny Holloway (left) supervises the upstairs switchboard in 1948. The operators had to memorize frequently used numbers and handle emergency calls. The International Telephone and Telegraph (ITT) switchboard, which used relays for switching, was one of the most reliable pieces of equipment available at the time. Some of these units were installed 40 years ago in developing countries and are still working. The Gilroy Telephone Company was acquired by General Telephone and eventually became part of Verizon.

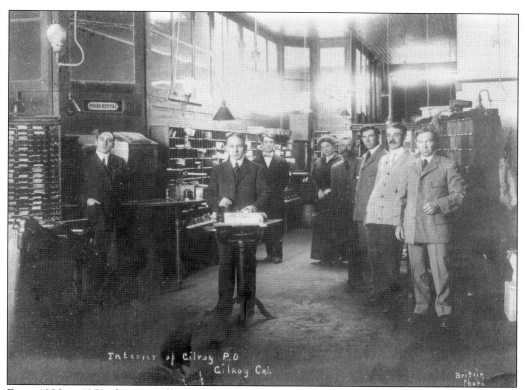

From 1920 to 1953, the post office was housed in a brick building constructed by William Radke at 60 Sixth Street. The postmistress was Catherine Ryan, the widow of a previous postmaster. The facility later relocated to the Third Street site shown in the 1955 photograph below. It is now at 100 Third Street. (Courtesy of the Gilroy Museum.)

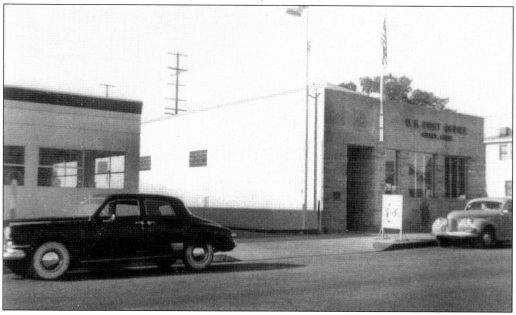

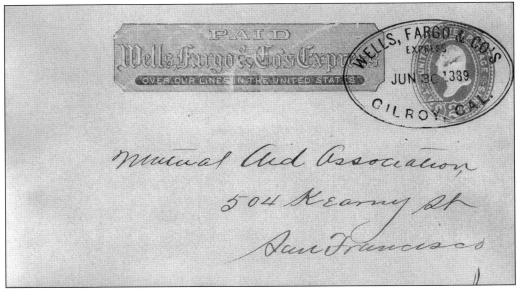

The first Gilroy postal office was in San Ysidro. Inn owner and postmaster James Houck was illiterate; he left a cigar box outside so the stagecoach could pick up and drop off mail. In 1889, Wells Fargo hired agent William Pyle, who was also employed by Western Union and as a city clerk. The station stood on Monterey Road at Fourth Street. (Courtesy of John Drew.)

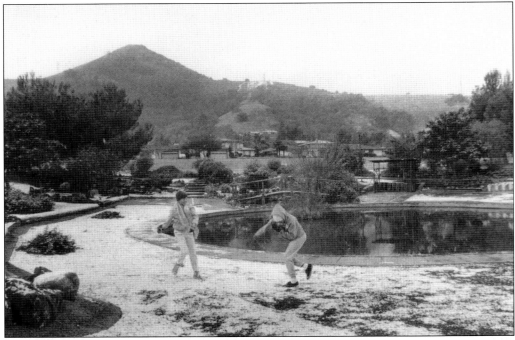

The area enjoys mild weather, with an average temperature of 57 degrees Fahrenheit in winter; however, every couple of decades it receives some snowfall. The snow remains on the ground for a few hours and generates a great deal of excitement for the dogs and children who have never seen it before. Here people are throwing snowballs at each other north of the Morgan Hill City Hall.

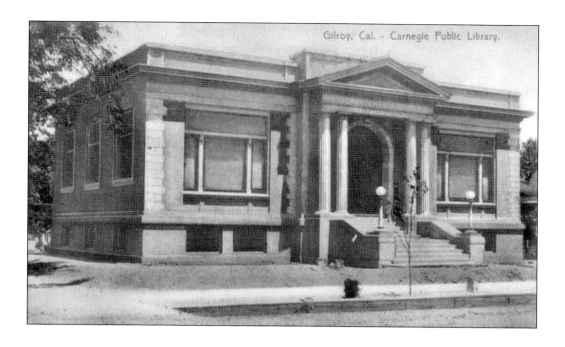

Gilroy postmistress Catherine Ryan and Caroline Hoxett campaigned for a library, which they believed was essential for the community. A donation from the Carnegie family in 1910 made it possible. The Revival library building, designed by William Weeks, is pictured here in 1915, after which it continued to serve the community for the next 60 years. Today only two library buildings of this type exist in the county. The other was at Santa Clara and Twenty-fourth Streets in San José, as shown in this 1926 photograph; it is now the San José East Branch (also known as EK). (Courtesy of the California Room, San José Public Library.)

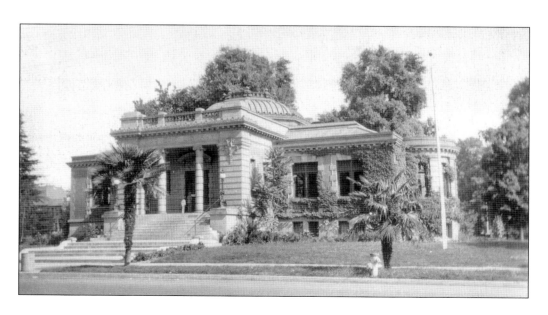

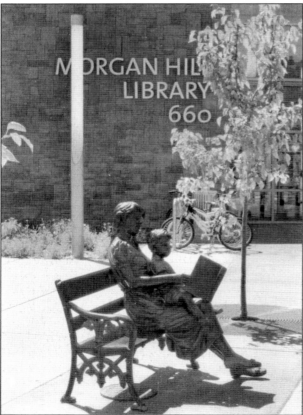

Morgan Hill's library, which originally stood next to the city hall on Monterey Road, started with one room and gradually expanded. Above, the library is covered with snow flurries in the 1970s. In 2007, Santa Clara County allocated funds for a new library at 660 East Main Street. It features a view of El Toro and even has a playground for children.

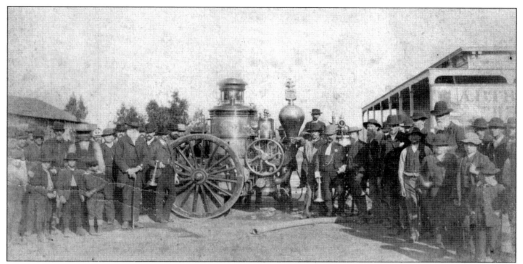

After Gilroy was incorporated in 1867, its hand-pumped fire engine was replaced by an engine using rotary governor-controlled steam. The first piston steam engine in Gilroy, pictured here in the 1890s, was made by the American LaFrance Fire Engine Company. The right rear engine is No. 5, which appears in many historic views. By 1916, American LaFrance was producing a six-cylinder gasoline-powered pumping apparatus that performed so well it literally put an end to the old steam engines.

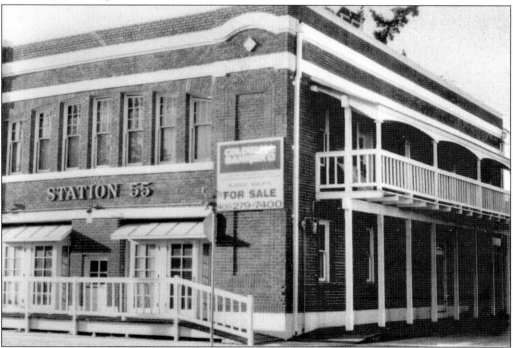

In 1916, Gilroy's own fire station was built by William Radke at 55 Fifth Street. The station had one paid staff. It was closed in 1978, and the building now houses a pizza restaurant. In spite of more efficient firefighting systems, frequent fires wiped out various downtown buildings. The Felice cannery completely burned down in the 1930s.

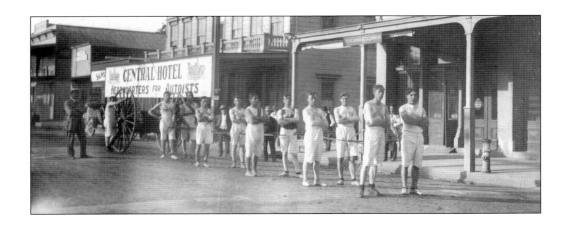

The earlier fire engines were hand pumped and often pulled by firemen. Two volunteer firefighter teams were in existence by 1871, and the volunteers would race against each other. This team of 12 firemen was from the Vigilant Engine Company, which had its station on Lewis near Monterey Road. The two in the back had to turn and steer the big wheels. This photograph was taken on Monterey Road in front of Wells Fargo Express during a July Fourth parade. In the undated 19th-century photograph below is another team also along Monterey Road in front of Riley's store.

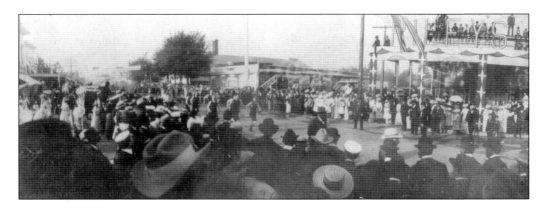

Nine

SCHOOLS

California Law No. 7531 stipulated each board of education to appoint a census marshal before June 1 of each year and notify the county of such appointment. The marshal was required to take census of all students age 15 and under and separate all the races. In this letter, Irving P. Henning (age 29, owner of $10,000 in real property and $4,665 in personal effects) has been appointed by board trustees José Jésus Bernal (age 31, owner of $9,000 and $3,000 in assets) and Henning himself. Both owned much of the land within the school district in 1871. (See page 9 for the Bernal house.)

APPOINTMENT

OF A

SCHOOL CENSUS MARSHAL.

[SEE REVISED SCHOOL LAW, SECTION 43.]

WE, the undersigned, Trustees of Public Schools for *Oak Grove* District, in the County of *Santa Clara* , hereby appoint *Irving Henning* a School Census Marshal for said District, to take the school census during the month of June in the present year, according to the provisions of Section 43 of the Revised School Law.

You will make a full report in writing, under oath, to the County Superintendent, and deliver a certified copy thereof to the School Trustees of said District, if they require it, on or before the first day of July next after your appointment. You will not fail to make full and correct returns of all statistics required, under penalty of forfeiting all compensation for your services.

J. P. Henning

Jose Jesus Bernal

Trustees of Public Schools for *Oak Grove* District.

DATED *May 20 th,* , 1871.

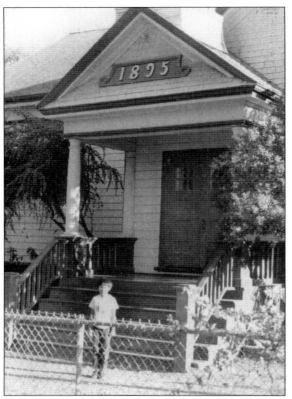

Barney Machado married one of the Murphys and obtained some land. In 1894, his ranch comprised 1,700 acres along Watsonville Road. Machado donated the land to provide neighborhood children with an education, and the neighbors built a one-room school on Sycamore Avenue in 1895. Here Jason Shueh stands in front of the school when it was in use. Until closing down in the 1980s, the facility had two classrooms and two teachers.

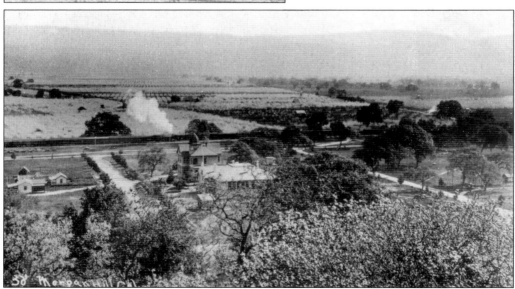

A Southern Pacific train passes through this bird's-eye view of the Morgan Hill School and the valley. At a cost of $4,000, the grammar school was built east of the Grange Hall on East Fourth Street in 1895. Students had to attend classes in the nearby Methodist church until the building's completion. This photograph was taken at Knob Hill, west of Monterey Road, in the late 1890s.

Rather than placing their hands in front of their hearts to pledge allegiance to the country, students used to salute the flag with the right arm extended and the palm facing upward, as if to raise the flag. Seen here is a flag-raising ceremony sometime during 1931. The Morgan Hill School, designed by William Weeks, was a concrete building 140 feet long and 165 feet deep. Opened in 1908, it was closed due to obsolescence and traffic. The building has been carefully razed and relocated to Llagas Road (as seen below). The old site has been replaced by a community and cultural center.

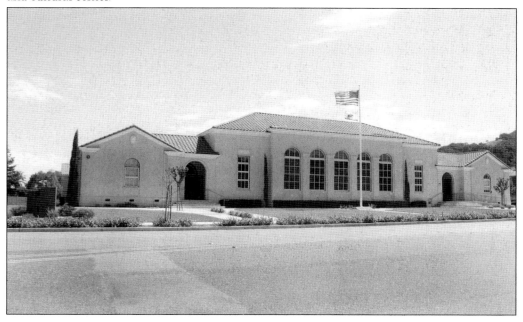

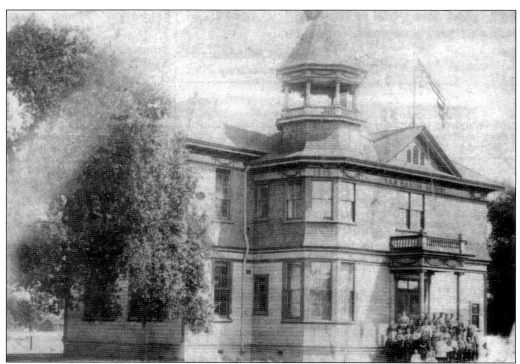

At the San Martin Elementary School, opening in 1895, one teacher instructed several classes. As it was in rural schools, older students were selected as aides to teach lower-class pupils. The single school has since been broken up as Gwenn and San Martin Elementary Schools.

Report of	*Clinton Mosher*													
Fourth Year							School							

For year ending June 19 22.

SUBJECT	1	2	3	4	5	6	7	8	9	10	PERSONALITY	1	2	3	4	5	6	7	8	9	
Arithmetic	2	2	/-	1	2	/	/-	/-	-	/-	Deportment	/	/	/	/	/	/	/	/-	/-	/-
Grammar	2	2	2	2	3	2	/-	2	2	2	Attendance	85	85	85	10	8	90	100	100	10	103
Reading	2	/-	/-	/-	/-	/	/	/-	/-	/	Effort										
Spelling	/-	/-	/	/	/	/	/	/	/	/	Attention										
Geography	2	2	/	2	/	/	3	3	2	/	Neatness										
History											Rapid Worker										
English											Careless										
Writing	3-	2	2	2	2	2	3	2	2		Dependent in study										
Drawing	/	2	/	/	2	2	2	2	2	2	Wastes Time							?	?		
Manual Training	/	2	/	/	/	2	2	/-	/-	-	Shows Improvement										
Domestic Science											Promotion in Danger										
Physical Education		/	/	/	/	/	/	/	/	/	*Citizenship*							/-		/-	
Music	2	/-	/	/	/	/	/	/	/												
Domestic Art																					
Average																					
Promotion Av.											*Mabel Merrill Balzari* Teacher.										
Honorary											*Mary C.* Principal.										

Fourth-grade student Clinton Mosher's report card reveals that he wasted time during the seventh and eight reporting sessions, resulting in poorer grades in his geography class in 1922.

Schoolgirls prepare a hoop dance for teacher Ruth Forsyth in 1915. This scene most likely occurred at the Rucker, Adams, or San Ysidro grammar schools, according to Gilroy historian Tom Howard. (Courtesy of the Gilroy Museum.)

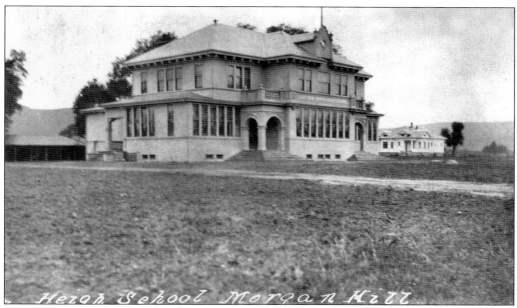

The original Live Oak High School was built on Central Avenue in 1906. Graduates of five elementary schools attended the new facility. The 1908 yearbook, *La Encina*, showed eight senior girls and one boy. The following year saw six in the graduating class. This photograph reveals Live Oak "Heigh" School (note misspelling) in 1935. Around 1971, the high school moved to its current location on East Main Street. The old site has become the Lewis H. Britton Middle School, named for a former principal.

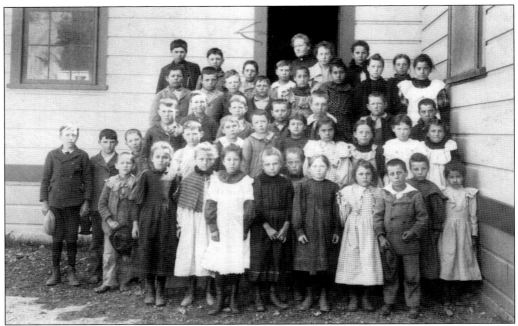

San Ysidro lies just west of Gilroy along Pacheco Pass. This is probably one of the earliest surviving photographs of the 43 students in Nelle Rice's 1896 class. In those days, it was not uncommon to teach many or all grades. Only a handful of students stayed after the school year, as many had to help families and many traveled south of the border. San Ysidro is now a school district with five schools. Some students wore no shoes. (Courtesy of the Gilroy Museum.)

In 1871, the California State Normal School built a huge campus at present-day Washington Square Park and produced the largest number of teachers. Today it enrolls over 30,000 students and has more alumni in the area than any other university. The World War I cease fire prompted girls to pose for a "peace" graduation portrait in 1918. (Courtesy of the California Room, San José Public Library.)

Ten

CELEBRATIONS AND EVENTS

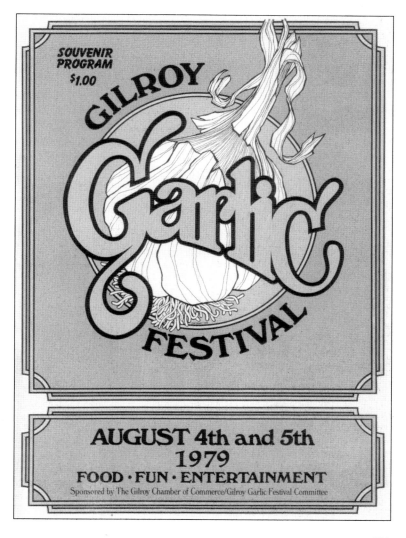

Gilroy's Garlic Festival has attracted more than three million visitors since 1979. Each event consumes two tons of garlic and raises more than $7.5 million, which is then distributed to various nonprofit groups and charities.

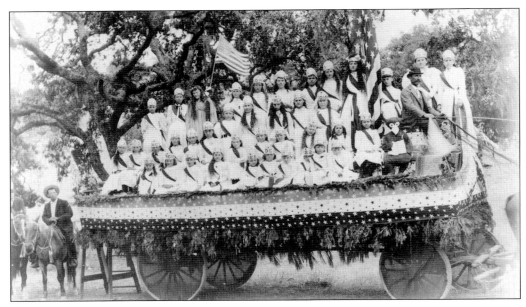

Except for a brief interruption in the 1940s, Morgan Hill has hosted a parade every year since 1895. Many hours were spent decorating this float for the first parade. Except for the Statue of Liberty and the California bear, each character wore a headband with the name of a state. Although they were all supposed to be females, some in the back appear to be boys wearing wigs; small towns do not have an ample supply of one gender and must often improvise. The Fourth of July parade is always followed by an outdoor picnic or barbecue. Spectators have used any available means of transportation, including bicycles and horse-drawn wagons. Below, this photograph of the 1915 picnic appears to have been taken on the eastern edge of Morgan Hill. Note the lady at front right posing with a bicycle, indicating that it was acceptable for females to ride them.

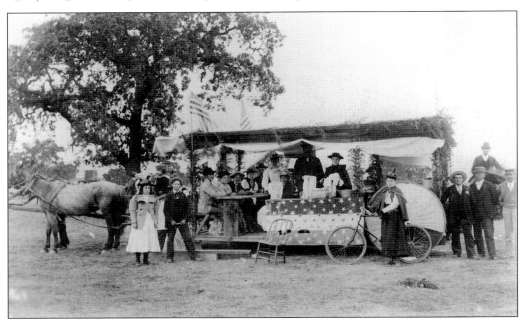

After the Morgan Hill City Hall moved to Peak Street, all of the city's Fourth of July parades have originated there. The Live Oak High School marching band, the Emerald Regime, is shown in a 1984 parade; the group was voted the best high school band in the country in 1978. Horse-drawn Wells Fargo stagecoaches (below) are popular even today. With so many horses in the parade, volunteers with wheelbarrows and shovels remind that before automobile pollution there were problems with animal droppings.

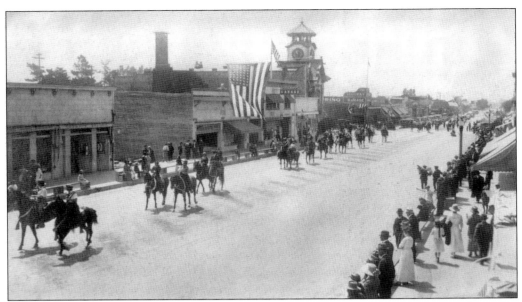

The City of Gilroy also holds irregular parades, including this Fourth of July parade in the 1920s. The view looks south on Monterey Road.

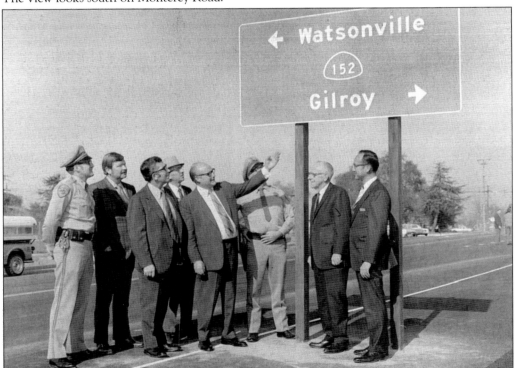

Santa Teresa Boulevard was built to connect Gilroy to the Almaden Expressway, a distance of more than 20 miles. The groundbreaking ceremony was held on January 24, 1972. For the most part, the boulevard has been completed but not as a four-lane road. (Courtesy of the Santa Clara County Archives.)

Each year, the Santa Clara County Fairground hosts a fair with lots of activities, including beauty contests. In this 1960s photograph, Miss Morgan Hill and Miss Willow Glen stand in front, while contestants from Alum Rock, Hillsdale, Mountain View, and other districts smile in the back.

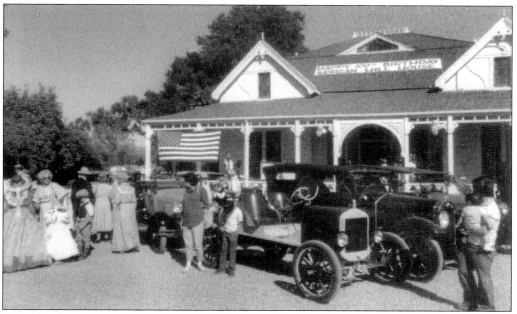

Villa Mira Monte, meaning "View of the Hill," was a Queen Anne–style house built for H. Morgan and Diana Murphy Hill as a summer home. Constructed of redwood lumber from the Santa Cruz Mountains, it was completed in 1886. Because the Hills owned the entire area, the train stopped at their back door. Pictured here is an event celebrating the centennial anniversary of the house, located at 17600 Monterey Road (formerly El Camino Real).

Woman's Christian Temperance Union
of California

MRS. O. J. WARD
Superintendent of Health and Heredity
Morgan Hill, Cal.

Santa Clara County had plenty of wineries, and little towns like Morgan Hill had saloons. Local women joined the nationwide fight against alcohol consumption. In the second decade of the 20th century, Mrs. O. J. Ward (second row, third from left) was elected superintendent of health and heredity for the Women's Christian Temperance Union of California. Below, several prominent wives, including Mrs. Acton, Mrs. Bagwill, Mrs. Weller, Mrs. Cochran, and Mrs. Purchell, supported her efforts to stop men from indulging in alcohol. Anyone who really wanted a drink, however, could simply go to the next town, where bars as long as 40 feet were documented. (Courtesy of Paul and John Ward.)

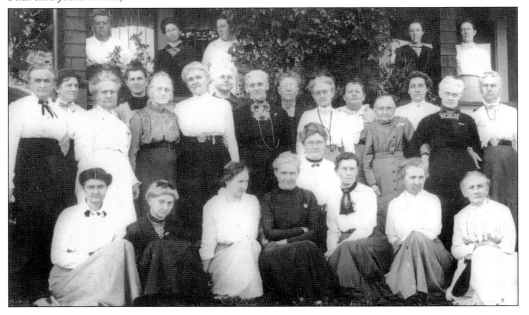

BIBLIOGRAPHY

Balkovek, G. "History of the Morgan Hill Times and San Martin News." Master's thesis, San José State University, 1973.

Engle, J. "A Taste of History." *Dispatch*. November 27, 2001.

Furia y Muerto: Los Banditos Chicanos. Los Angeles: Aztlan Publications, 1973.

Gilroy–Morgan Hill–San Martin City Telephone Directory, 1907–1930.

Morgan Hill Times, April 12, 1894–present.

Munro-Frazer, J. P. *History of Santa Clara County, California*. San Francisco: Alley, Bowen, and Company, 1881.

San José Mercury News, 1896.

Sawyer, Eugene T. *History of Santa Clara County, California, with Biographical Sketches*. Claire, NV: Historic Record Company, 1922.

Scettrini, L. "The Downtown Morgan Hill Historical Preservation Survey." Gilroy, CA: Public History Services, 1979.

Shueh, S. "California Ghost Town Postal Stations." *GSN Quarterly*. September 1993: 36–37.

———. "History of 21 Mile Station." *Morgan Hill Times*. Accepted for publication, 2007.

———. "John M. Browne: Early Pioneer of Gilroy." *South County News*. June–July 2005: 4-7.

———. "Juan Hernandez: Early Landowner and Pioneer of Morgan Hill." *South San José to Hollister South County News*. October–November 2007: 28.

U.S. Census, 1870–2000.

Valley of Heart's Delight. KPIX. Written and narrated by Don Brice.

Wyman, B. "History of Morgan Hill, California, from Indians to Incorporation." Master's thesis, San José State University, 1982.

ACROSS AMERICA, PEOPLE ARE DISCOVERING SOMETHING WONDERFUL. *THEIR HERITAGE.*

Arcadia Publishing is the leading local history publisher in the United States. With more than 4,000 titles in print and hundreds of new titles released every year, Arcadia has extensive specialized experience chronicling the history of communities and celebrating America's hidden stories, bringing to life the people, places, and events from the past. To discover the history of other communities across the nation, please visit:

www.arcadiapublishing.com

Customized search tools allow you to find regional history books about the town where you grew up, the cities where your friends and family live, the town where your parents met, or even that retirement spot you've been dreaming about.